Figure in the Garden

Katharina Fritsch at The Museum of Modern Art

Figure in the Garden

Katharina Fritsch at The Museum of Modern Art

Edited by Robert Fleck
Contributions by Katharina Fritsch, Tom Otterness, and Ann Temkin

Verlag der Buchhandlung Walther König, Köln

Table of Contents

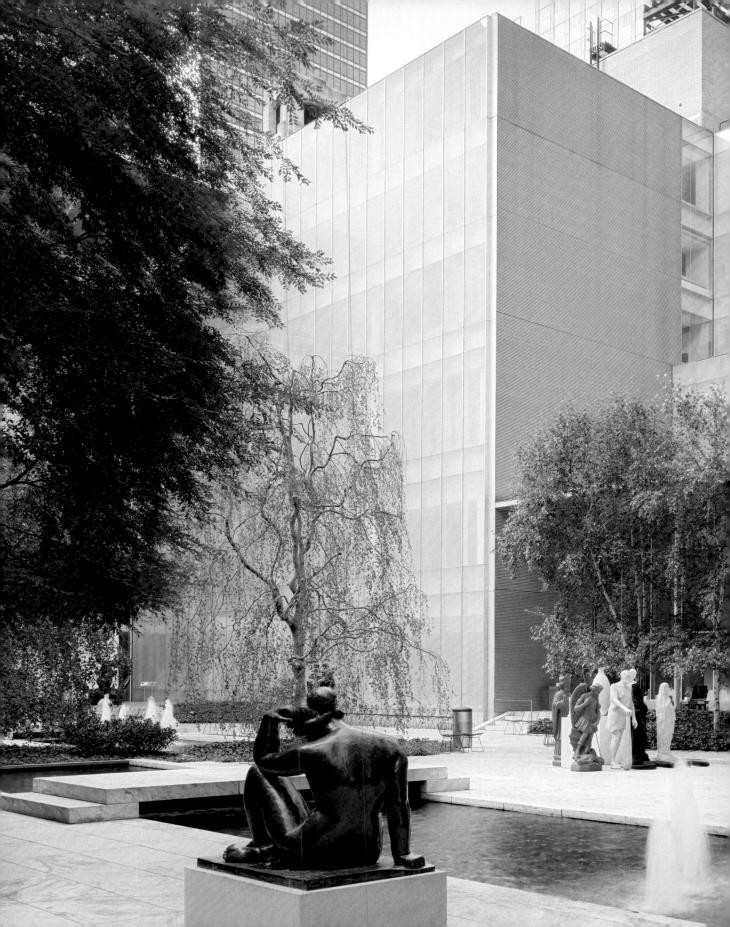

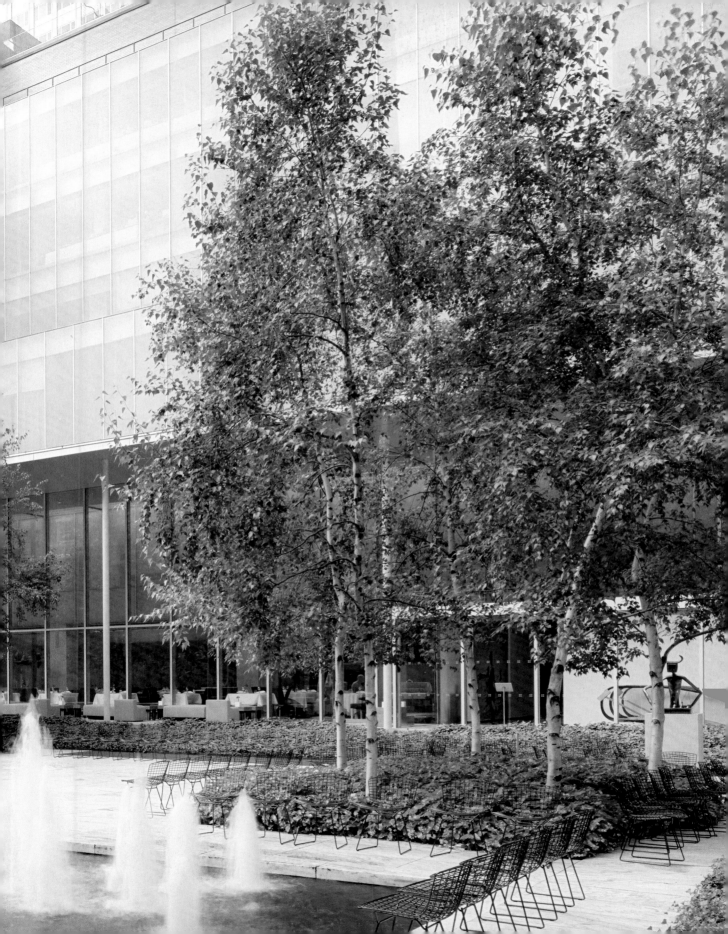

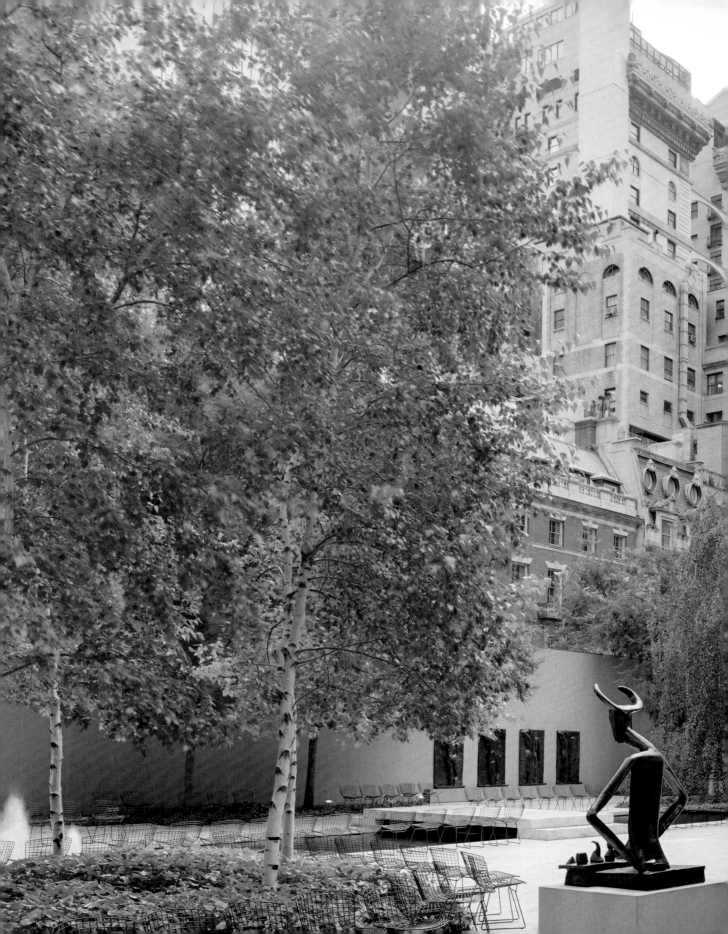

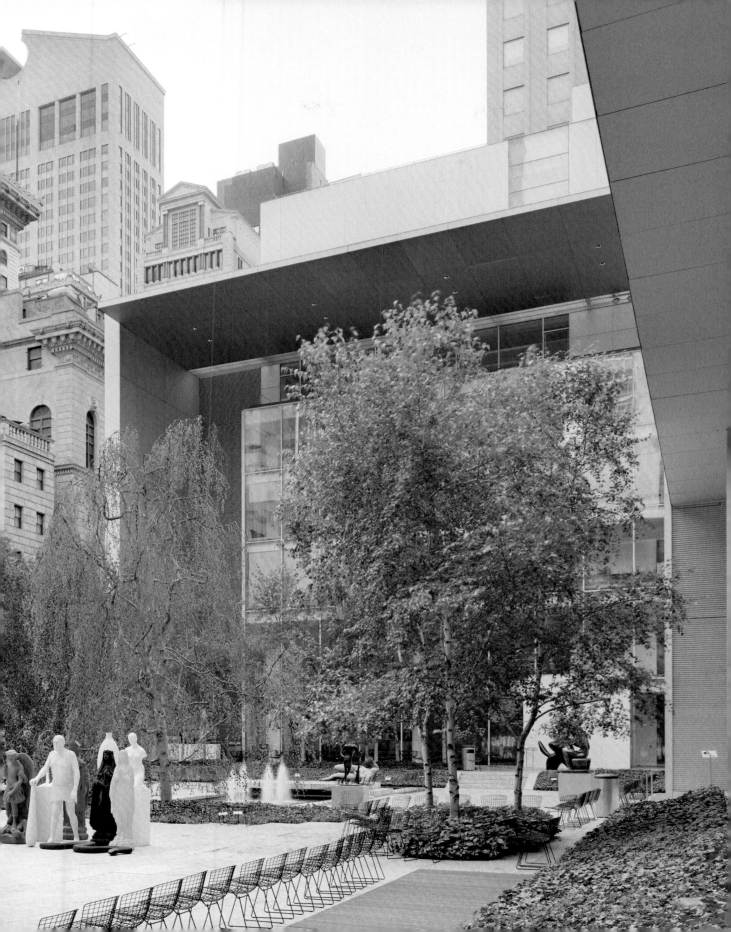

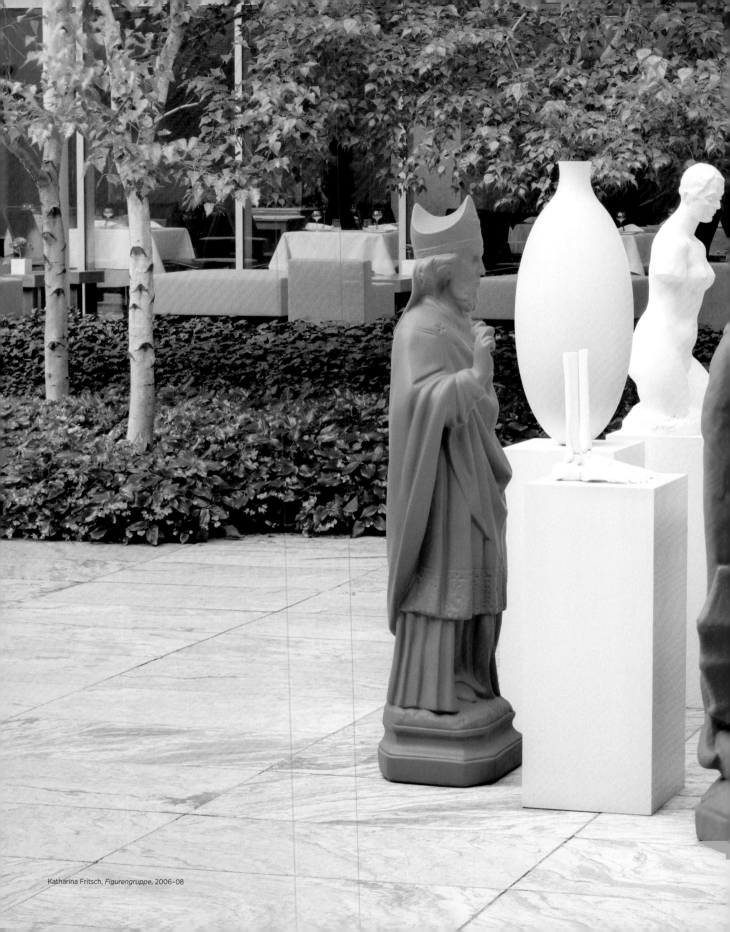

Katharina Fritsch, *Figurengruppe*, 2006–08

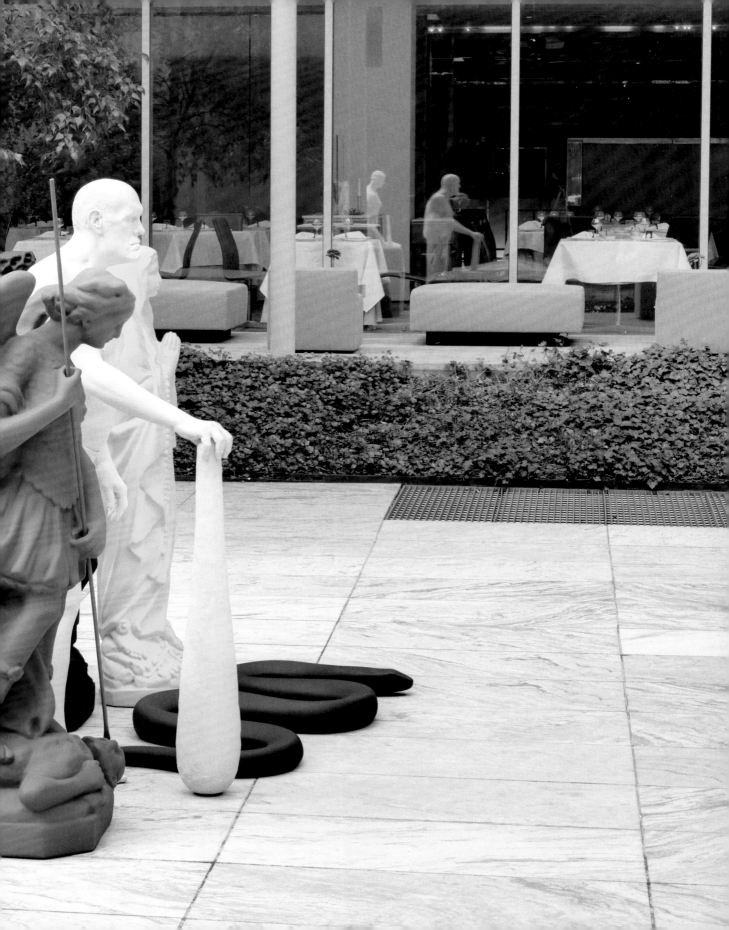

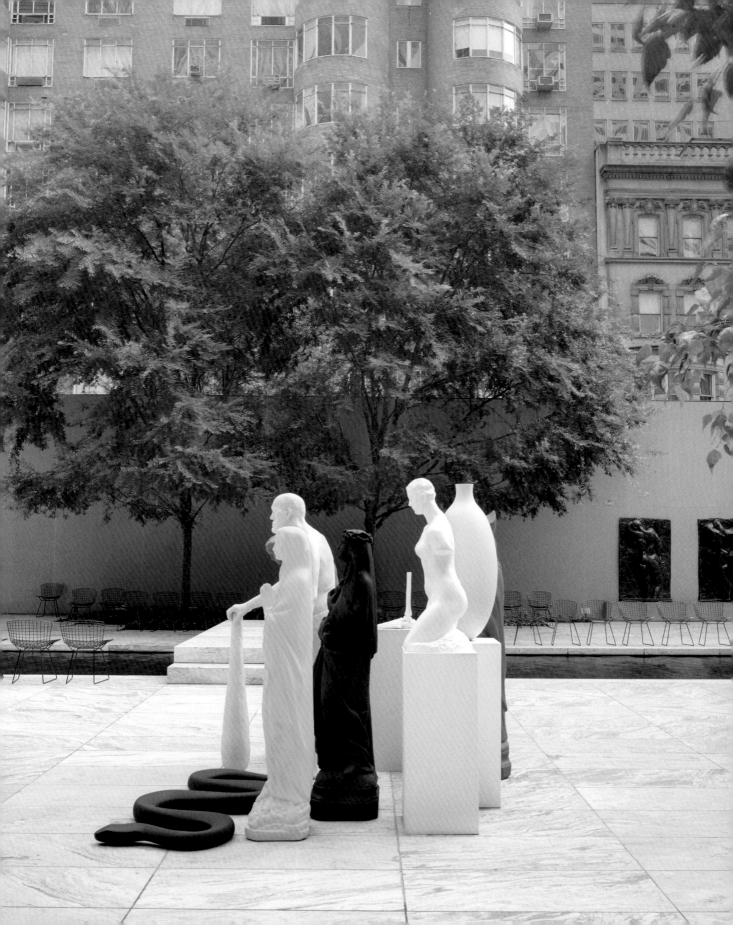

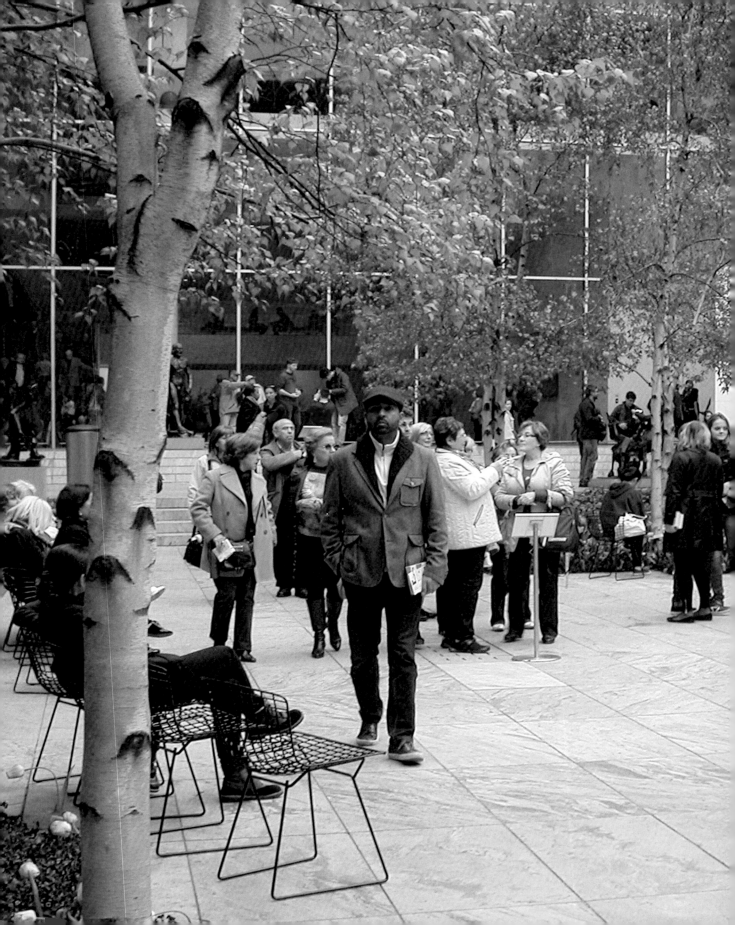

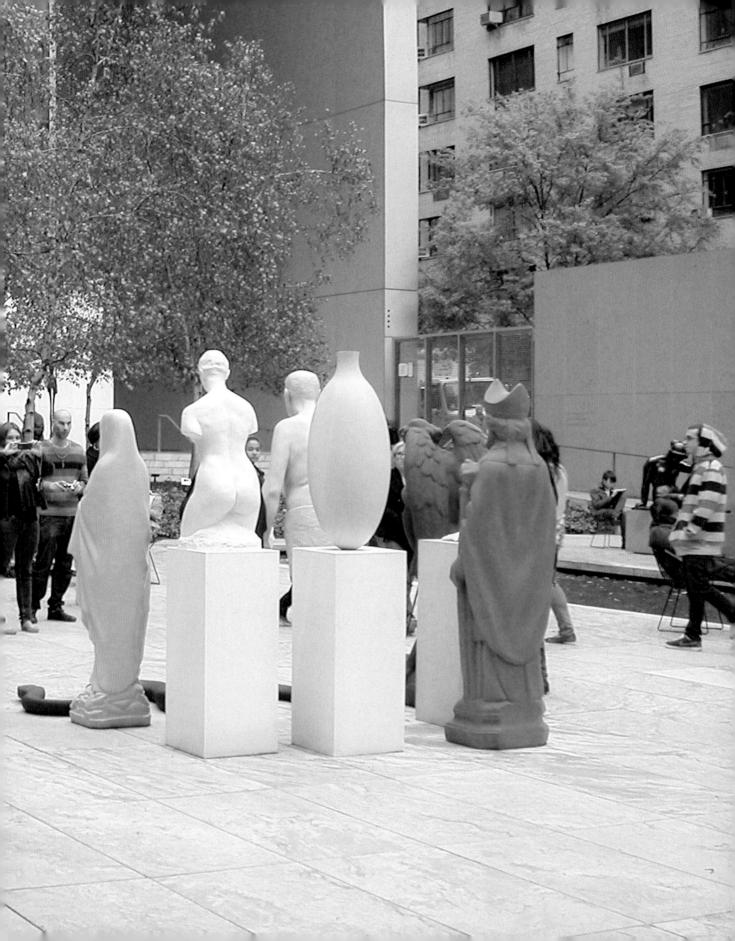

Figure in the Garden

Robert Fleck

Standing in a square open space is a group of figures. Their bright colors lure viewers in, but up close the individual figures, with their matte monochrome finish, look unreal, like apparitions. The morphological quality of this *Figuren-gruppe* (Group of Figures, 2006–08) elicits an immediate reaction. But, with its internal contradictions and symbolic references to disparate religious and cultural contexts, the group presents an enigmatic puzzle, triggering allusions to each viewer's own life experience and cultural background.

Figurengruppe is the work of Katharina Fritsch. It is part of the 2011–2013 exhibition "Figure in the Garden" at the center of The Museum of Modern Art's Sculpture Garden. The museum acquired this substantial work in 2009, a gift by Maja Oeri and Hans Bodenmann. Ann Temkin, the museum's Marie-Josée and Henry Kravis Chief Curator of Painting and Sculpture, felt that *Figurengruppe* exemplified sculpture's step into the new millennium.

For years Fritsch has explored and emphasized polychrome and freely composed asymmetrical sculpture. In the museum's long tradition of acquisitions, *Figurengruppe* is the first large, multicolored, multi-part sculpture to be purchased. Indeed, the exhibition's arrangement around *Figurengruppe* is what makes "Figure in the Garden" so interesting. Works by Auguste Rodin, Aristide Maillol, Pablo Picasso, Henri Matisse, Max Ernst, Alberto Giacometti, Renée Sintenis, Elie Nadelman, Gaston Lachaise, Joan Miró, Henry Moore, and Tom Otterness are shown in terms of their ability to converse with and relate spa-

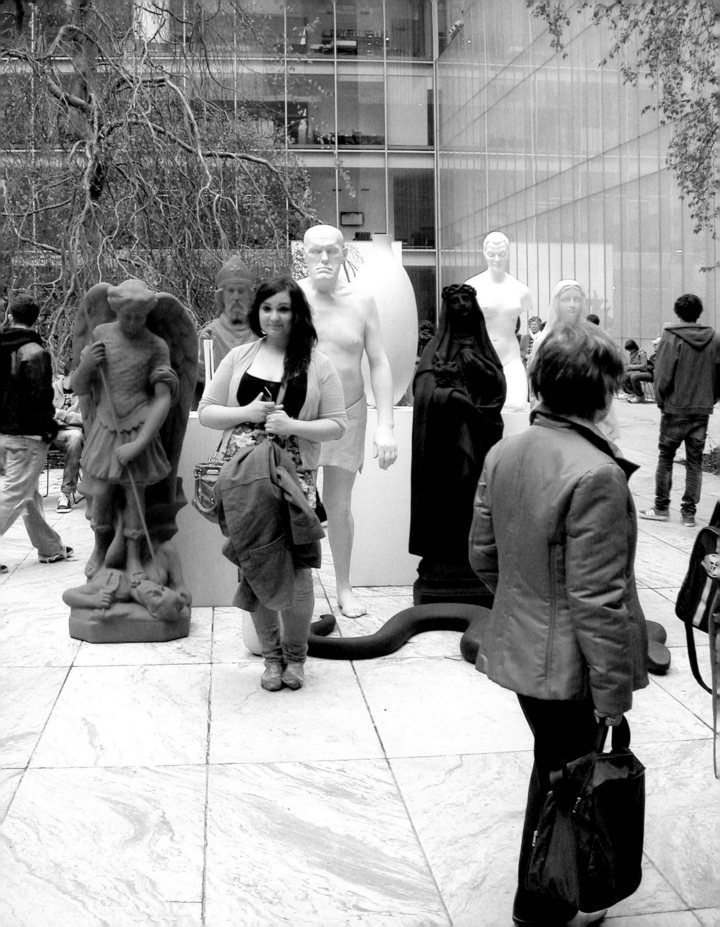

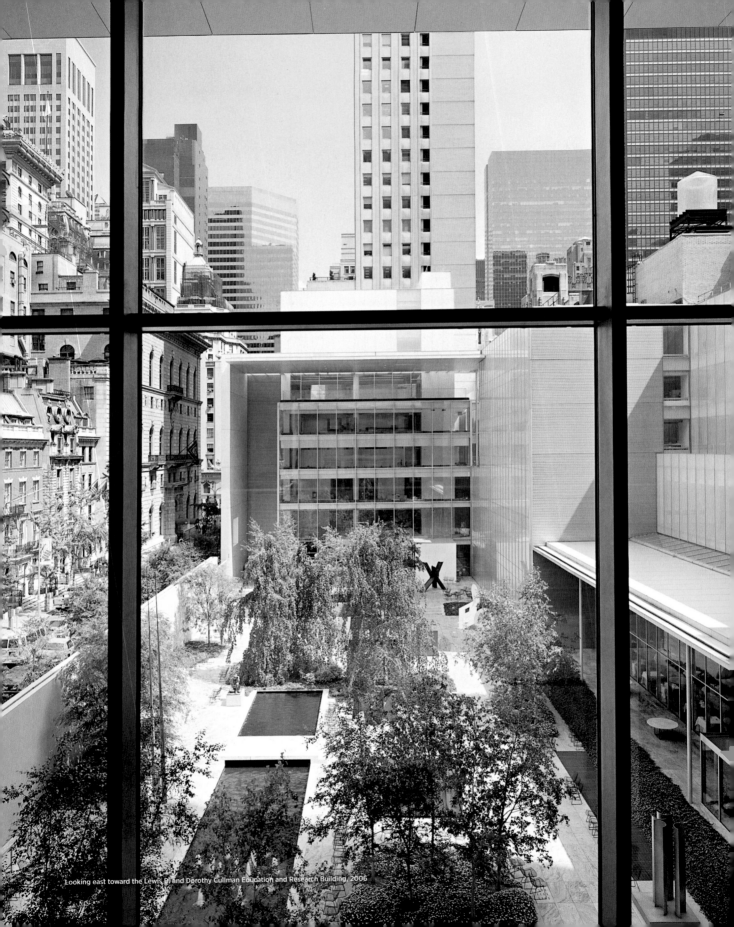

Looking east toward the Lewis B. and Dorothy Cullman Education and Research Building, 2006

Tom Otterness, *Head* (1988–89)

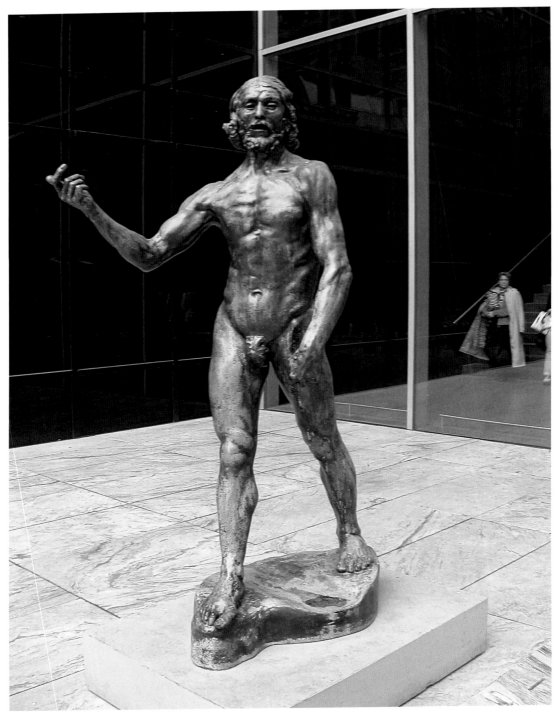

Auguste Rodin, *Saint Jean Baptiste prêchant* (1878–80)

Figure in the Garden

tially to each other. Featuring sixteen bronze sculptures from the last 130 years, "Figure in the Garden" does not just represent an overview of figurative sculpture since 1880; Temkin has put the cart before the horse, reading the history of the figure in the sculpture collection from the present day back to the beginnings of modern sculpture. "Figure in the Garden" starts with Fritsch's group and positions the other sculptures in relation to it. In doing so, the exhibition poses many interesting questions about both the history of sculpture and shifts in sculpture today.

Surrounding Fritsch's *Figurengruppe* are unpainted bronze sculptures, which together appear like a ballet of posing, stepping, cowering bodies emerging from the ground and imposing themselves within the space. In the center, Fritsch's mysterious, colorful figures and objects stand motionless. The exhibition traces a path from the present day, from the apparitions of corporeality in Fritsch's work, to Rodin's early masterpiece *Saint Jean Baptiste prêchant* (St. John the Baptist Preaching, 1878–80). Remarkably, the two works by living artists seem to slot almost naturally into an equal relationship with key landmarks in Modernist figurative sculpture.

Both in Fritsch's work and in Tom Otterness's *Head* (1988–89), the other contemporary work in the exhibition, innovative breaks with this earlier tradition can be read. In *Head* we see considerable innovations with regard to the body, the object, and the tradition of bronze sculpture, and these innovations are accentuated in *Figurengruppe*.

The nine objects, or rather sculptures, in *Figurengruppe* have a formal austerity that reveals Minimal Art to be their model, while their frontality, plurality, polychromy, and verticality, as well as their figurativeness and their play with the plinth, consciously break a whole series of rules in Modernist sculpture. In "Figure in the Garden" this contrast clearly highlights the contemporary approach to human form and how concepts of the body have changed. Fritsch's figures are mechanically magnified everyday objects, each three-dimensional detached concrete shapes, modeled by hand and finished with monochrome matte paint. By contrast, Rodin, in the spirit of his contemporaries the Impressionists, undertook a heroic attempt to start from the living model in full movement, shaping his sculpture from the inside out.

Figurengruppe was first shown in 2009 as an outdoor sculpture in Fritsch's exhibition at Kunsthaus Zürich and later that year as the entrance piece to an exhibition at Hamburg's Deichtorhallen. Nine figures stand in a three-row formation. In the front row is a praying yellow Madonna, a black saint, a giant grey primeval man leaning on a club, and a chrome-oxide green Saint Michael. These four figures are of a comparable physical size. Before them slithers a black,

somewhat geometricized snake. The snake is more stylized in design than the bodies, making it look alien, like an *objet d'art*, yet familiar at the same time. Behind these yellow, black, grey, and dark green figures are four more, painted in a neutral grey with the exception of a purple saint behind the giant. This second row is characterized by mysterious references. A female torso, a skeletal fragment, and a geometric vase, each on a simple plinth, make *Figurengruppe* recognizable as an open allegory with topical references and multiple meanings. Polychromy unfolds in the first row while the grey of the remaining objects in dialog with the purple Saint Nicolas provide both spatial and allegorical depth.

Figurengruppe involves the "art of radical juxtaposition" – Susan Sontag's description of the formal principle shared by Pop Art, happenings, Minimal Art, and Conceptual Art.[1] This sculpture emerged through the combining of a number of existing works the artist had produced independently of each other in her Düsseldorf studio since 2003, before the coloring was decided – which is in fact what gives the piece its impact. It can be read as a "real allegory" composed of transformed elements of reality, as in Gustave Courbet's famous painting *L'Atelier du peintre, allégorie réelle déterminant une phase de sept années de ma vie artistique* (The Artist's Studio, a Real Allegory Summing up Seven Years of My Artistic and Moral Life, 1854–55).[2] Finishing the figures, previously made in light polyester between 2006 and 2008, to create a weatherproof painted metal sculpture for the Sculpture Garden (using galvanoplastic coatings on bronze) gave the work additional force. Like Courbet, Fritsch uses no familiar images of the present, but *Figurengruppe* examines the direct impact of figures that play a role in our collective consciousness. Their poignancy is reinforced by color, and it gains ambiguity through a matte finish that transforms them into indeterminate apparitions.

If we see *Figurengruppe* as a "real allegory" we notice that, like Courbet's painting, it consists of *tableaux* – images that are seemingly easy to categorize, images that present a personal universe but are not directly connected with the world of contemporary public imagery. In its content-based references, from the Madonna through to the fragments on plinths, *Figurengruppe* is not directly accessible. All nine figures boast a high degree of naturalism – the grey giant, for instance, is a taxi driver given sculptural dimensions – but are not bound to contemporary narratives, to the media topics and imagery of our era. The figures take on their openly allegorical quality because they are realistic, contemporary, and, at the same time, reference-less within contemporary discourse. It seems there are no concrete meanings, allusions, or contexts anymore in the dispersed references of our postmodern age. It is precisely in dispensing with

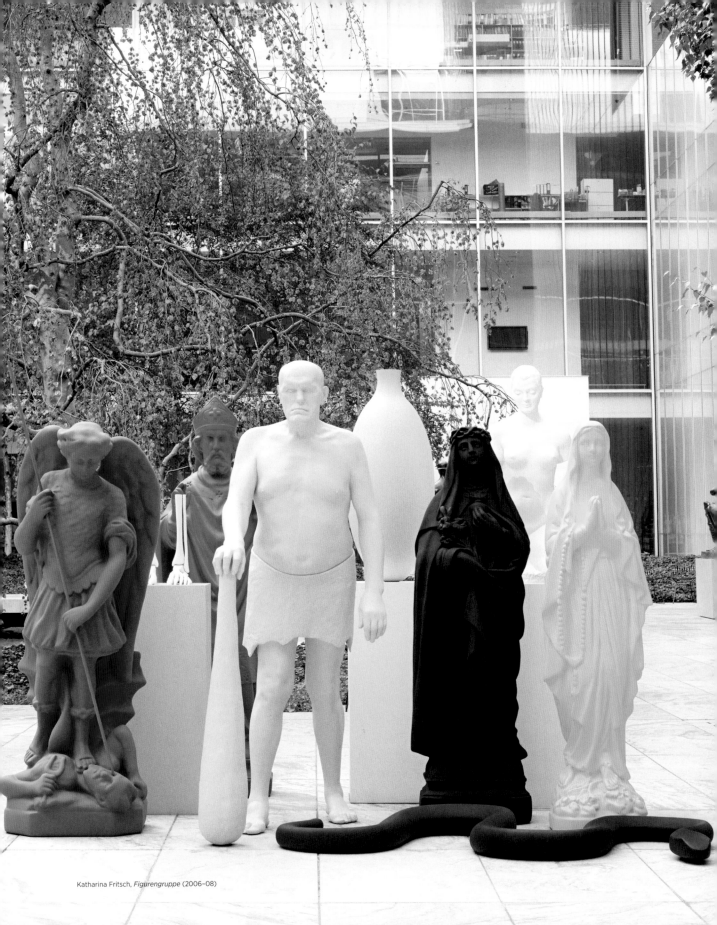

Katharina Fritsch, *Figurengruppe* (2006–08)

references that the nine realistic figures, reaching out beyond current iconography, become contemporary allegories.

Their multicolored finish, both appealing and virtualizing, sets *Figurengruppe* apart from the other bronze sculptures in the Sculpture Garden. Obviously, it is by no means the only multicolored work of modern or contemporary sculpture; the works of Reiner Ruthenbeck, Sigmar Polke, and Gerhard Richter, as well as the multicolored sculptures of Donald Judd, can be detected here as early influences, as can, more specifically, the singular method of the artist's teacher at the Kunstakademie Düsseldorf, Fritz Schwegler, who brought together color and a performative notion of sculpture from 1972.

Fritsch sets herself apart from these modern role models with pure color tones and a matte finish that rules out any reflection of light. While Rodin's polished bronze is about highlighting three-dimensionality and the function of muscles through the play of light on a surface, bringing it to life through changing visual effects, in *Figurengruppe* the yellow, black, green, purple, and grey paint is applied to the figures with such monochrome uniformity that the surrounding light barely seems to strike them. Here every color is disconcerting in relation to the figure itself. The color choices are subjective yet not used expressively. The colors define the objects but also give them an unreal, apparition-like aura. This is paired with an interlocking tonal harmony.

Right at the entrance to the exhibition, an interesting dialogue already arises between the giant in Fritsch's ensemble and Rodin's *Saint Jean Baptiste prêchant*. While Rodin expresses his perception of nature in the constantly changing light – reminiscent of Claude Monet – Fritsch emphasizes the unreal quality of a very present figure that is sculpturally flawless. While Rodin's figure appears to develop from the inside out, the object quality of Fritsch's figures is manifest only in their form or shell. Their inorganic corporeality contrasts with Rodin's organic treatment of the body; the body is a standardized, unreal object. Rodin allowed his models to pace up and down in his studio while he modeled his sculptures. He placed representation of movement, as an expression of *élan vital*, at the center of his sculptural work. Hence John the Baptist's spontaneous arm gesture, which seems to destabilize the figure's posture and make its center of gravity appear off-kilter, as in many of the artist's later works. In contrast, movement and spatial dynamics, fundamental themes of Modernist sculpture, are rejected by Fritsch so as to highlight the object quality of the body.

Starting from this disparity, the "Figure in the Garden" exhibition shows how discerningly and sensitively these key twentieth-century sculptors dealt with movement and spatial dynamics. We are also struck by the different emphases made by the two contemporary artists, Otterness and Fritsch.

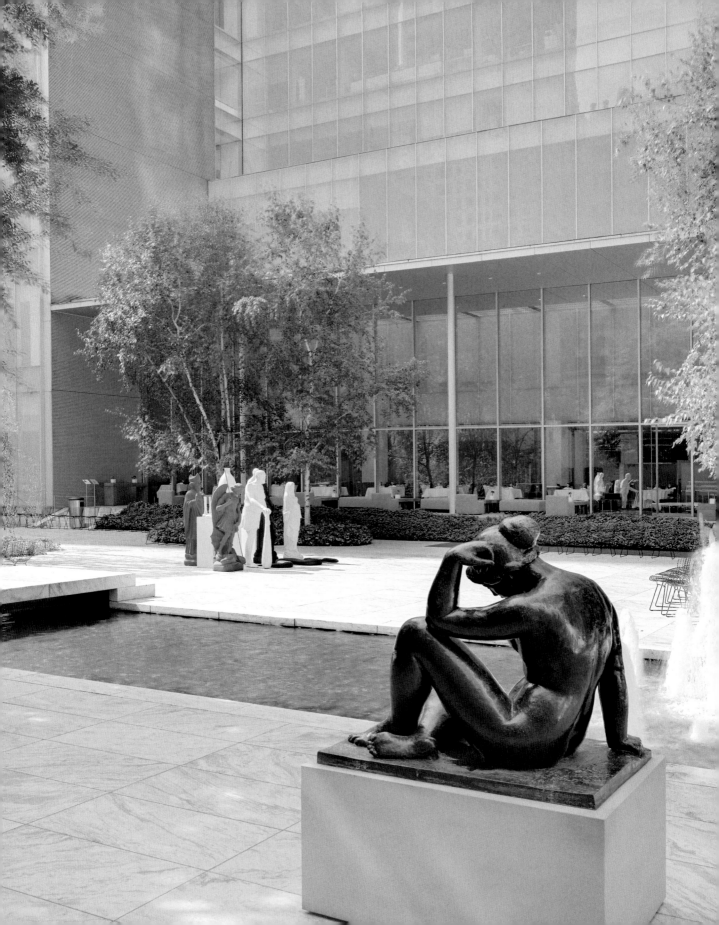

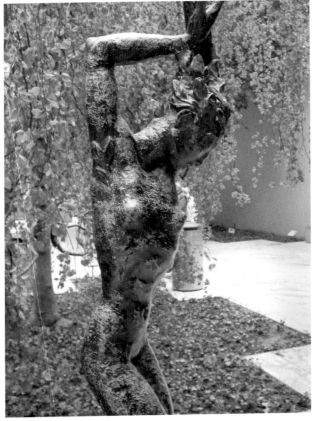

Renée Sintenis, *Daphne* (1930)

Aristide Maillol, *La Méditerranée* (1902–05)

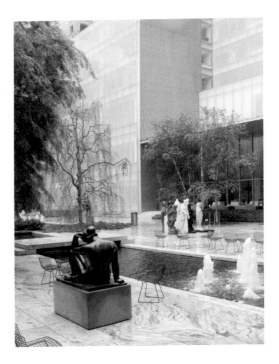

At the start of the twentieth century, Aristide Maillol modeled the sculpture *La Méditerranée* (The Mediterranean, 1902–05) from the inside out, albeit no longer in Rodin's impressionistic manner but with as much sensitivity. Consciously turning away from Rodin, he interpreted movement using the purest expression of tranquility. The sculpture's static, architectural nature, as well as Maillol's emphasis on the closed form, indicate the huge impact of this work on the sculptors of the first half of the twentieth century – including the Düsseldorf art student Wilhelm Lehmbruck, subject of a solo exhibition at The Museum of Modern Art in 1930, a year after its founding.

That same year, in *Daphne*, Renée Sintenis defined the theme of movement in a free, dancing form as the conquest of space and liberation of the body, thereby synthetizing the era's artistic movements: Cubism, Futurism, Constructivism, and Dada. Sintenis was a famous German sculptor represented by Galerie Flechtheim, and a professor in East and West Berlin after 1945 (during the student years of Georg Baselitz, among others). She would later design the emblematic *Berlin Bear*. In 1939 Museum of Modern Art acquired *Daphne*, making it one of the early works purchased for the sculpture collection. Part of the potential of continually and precisely curated collections – an example set by The Museum of Modern Art in the twentieth century – is that they keep us aware of artists who are as good as forgotten in their homelands and whose works have long since disappeared from the international art market. Without the repeated display of *Daphne* in the Sculpture Garden, Sintenis's work would have been forgotten in Germany, even though Berlin museums have several sculptures in their collections.[3] The last monograph on Sintenis appeared in the GDR in 1947.[4] The Museum of Modern Art may be the only museum with a piece by Sintenis currently on display, but her work in twentieth-century sculpture is quite remarkable – especially when we consider how difficult it was for female artists to pursue permanent self-employment as sculptors until the 1950s.

Situated between Maillol's early work and Sintenis's sculpture are Henri Matisse's bronze reliefs *Nu de dos I, II, III, and IV* (The Back I, II, III, and IV, 1908–31). Created independently of each other, these four works explore, in multiple ways, movement and duration, planarity and spatiality, corporeality and geometry, and contours and abstract surfaces. Three of the bas-reliefs were acquired in 1952 (during the artist's lifetime) and the fourth in 1956 (shortly after his death). This followed Alfred H. Barr Jr.'s pioneering 1951 monograph on Matisse,[5] and his 1946 book on Picasso.[6] The surrounding light is diffused by Matisse's "painterly" surface treatment of the bas-reliefs, the first of which was created at the same time as *Dance*, his series of great painting

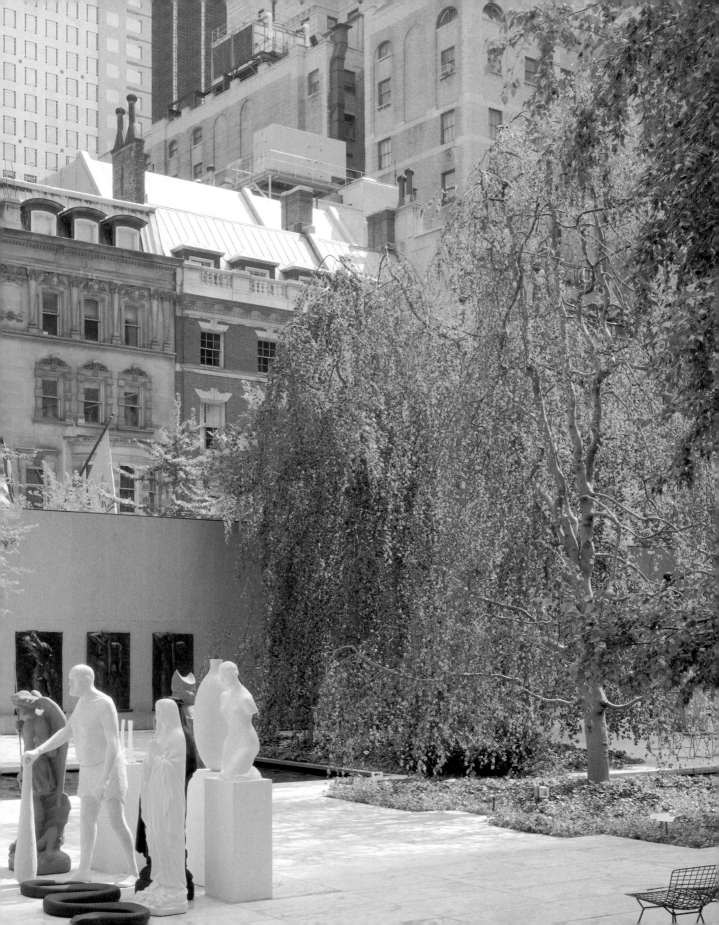

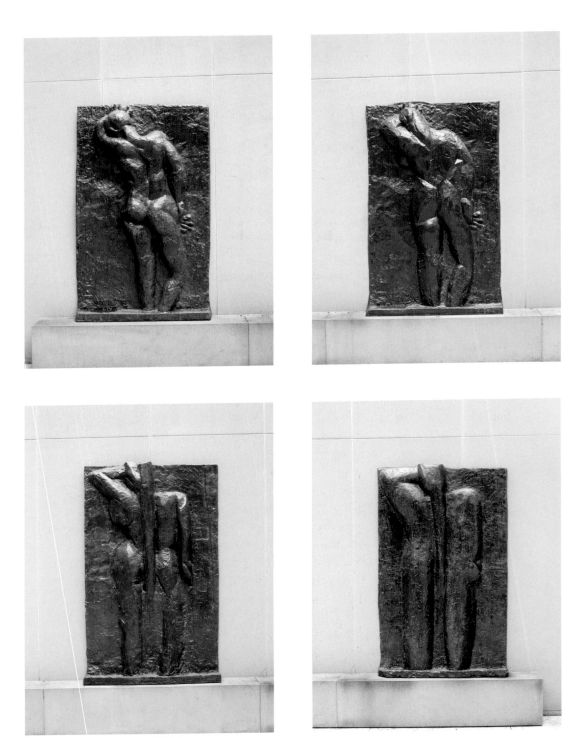

Henri Matisse, *Nu de dos I, II, III, and IV* (1908–31)

compositions. The four relief sculptures become respectively more two-dimensional and move toward an abstract language of signs while retaining the same clear form, elaborated organically through the observation of models. In their simultaneous presentation, not intended by the artist yet in line with the inner laws of his works, they take on a cinematographic quality that corresponds to the scenic nature of *Figurengruppe*.

Juxtapositions of this kind between sculptures from the collection – and in the immediate vicinity of the rest of the museum's permanent collection – tie in with the idea that prompted the creation of the Sculpture Garden between 1939 and 1953. Founded in New York in 1929, The Museum of Modern Art was an institution for exhibitions of influential twentieth-century art and did not initially possess a collection of its own. The Board of Trustees then decided to give the museum a lasting status, specifically by developing a collection of painting, sculpture, photography, film, architecture, and design that would be unrivaled.

By 1939 it was already the first institution to put those mediums on an equal footing, side by side. This approach was avowedly inspired by the Bauhaus and progressive German institutions such as the Folkwang Museum (then in Hagen) and the Landesmuseum Hannover (in particular, the exhibition practice of Alexander Dorner). The Museum of Modern Art – initially in rented premises at 5th Avenue and 57th Street and then, from 1932, in a building at the current location, 11 West 53rd Street – staged pioneering exhibitions, like "Cubism and Abstract Art" and "Dada, Fantastic Art and Surrealism" (both 1936), while in Europe artists were being silenced by the triumph of fascism and National Socialism, or driven to emigrate.

The first iteration of the Sculpture Garden could be seen in 1939 as part of the exhibition "Art in Our Time: 10th Anniversary Exhibition," which provided the most comprehensive overview to date of the art of classical Modernism. The exhibition coincided with the opening of the new building on 53rd Street designed by Philip L. Goodwin and Edward Durell Stone. Within this context, John D. Rockefeller – who donated the plot for the construction of the museum in 1936 and whose wife, Abby Aldrich Rockefeller, was a founding trustee – acquired in 1937 the land on 54th Street that is still home to the Sculpture Garden. At that time the Rockefellers had donated to the collection many Modernist sculptures, including works by Gaston Lachaise, Aristide Maillol, Wilhelm Lehmbruck, Henri Matisse, Amedeo Modigliani, and William Zorach. Understandably, the garden was eventually given the name the Abby Aldrich Rockefeller Sculpture Garden, in April 1953. (Abby Aldrich Rockefeller had died in 1948.[7])

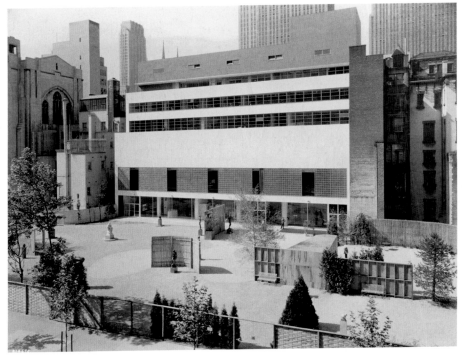

View to the southeast, 1939

In May 1939 founding Director Alfred H. Barr Jr. and John McAndrew, Curator of the Department of Architecture and Industrial Art, created the Sculpture Garden in the two weeks prior to the building's opening. They did this by structuring the space with curved screens and drapes in a shape inspired by Hans Arp. Alongside these screens, the sculptures themselves were also used to design the space. This was the first sculpture garden in a museum, an idea that may have been inspired by Rodin and Maillol, who had placed sculptures outside their studios. The Sculpture Garden therefore originated as a space within an exhibition (more than twenty of the sixty sculptures in "Art in Our Time" were displayed here) and not as a comparatively static outdoor area for permanent exhibitions, as came to be the case in most sculpture gardens set up by European museums in the late 1950s and early 1960s. The Museum of Modern Art still sees the Sculpture Garden as an "outside gallery" featuring temporary displays, not encyclopedic or chronological presentations of its collection. Nine years after its opening, Barr said, "Our original plan for the garden was of course just as anti-mechanistic as possible. We laid it out in free curves inspired by Arp, partly by English garden tradition with screens as background for the

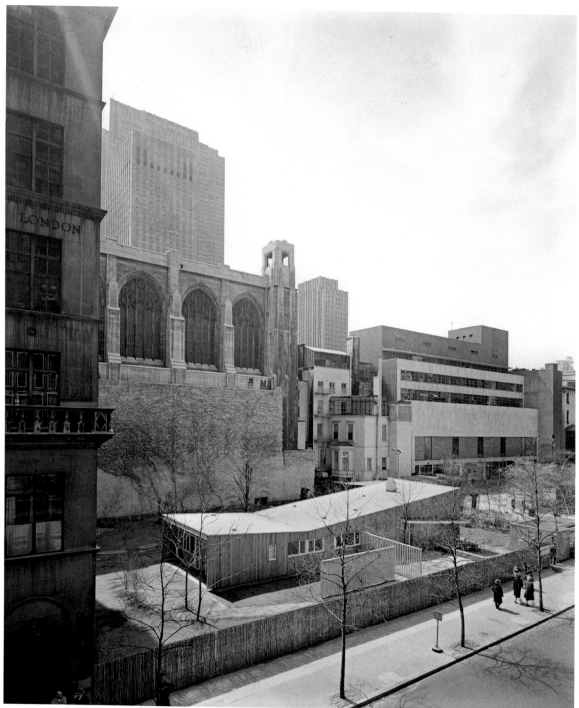

Marcel Breuer's House in the Museum Garden, 1949

Robert Fleck

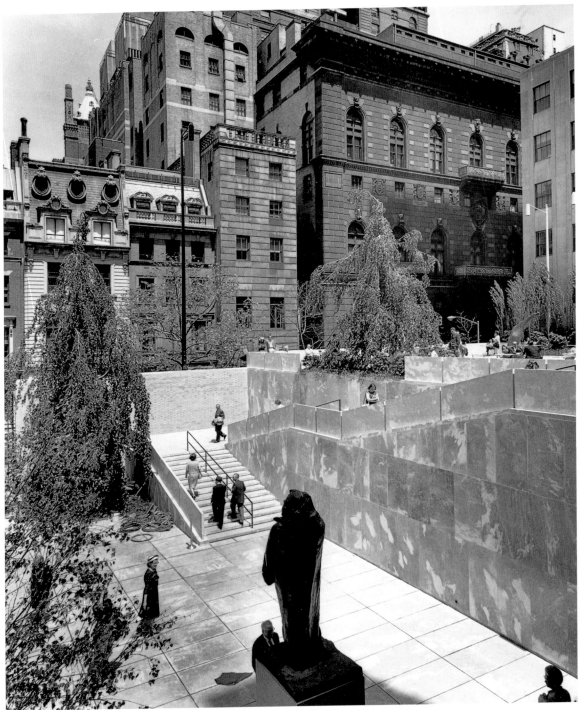

The garden was enlarged with the addition of an upper terrace and grand staircase designed by Philip Johnson, 1964

Figure in the Garden

sculpture and as much informal planting as we could afford. [...] The garden was designed to contrast with the severe rectangular layout of the rear façade of the Museum, not to mention the severe rectangular layout of the surrounding New York City."[8]

A large restaurant was opened in 1942 in the uncovered area on 54th Street. With the consolidation of the premises under new Director René d'Harnoncourt from 1949, and with the rehabilitation of Barr's role and ideas at the beginning of the 1950s, a redesign of the Sculpture Garden became a priority. The tender went to Philip Johnson.

Like Barr, and indeed sometimes with him, Johnson embarked on extended trips around Europe in the 1920s and 1930s, meeting various protagonists of classic Modernism. From 1932 to 1934 he was Director of the Architecture Department, before becoming an architect himself in 1936 at the suggestion of Mies van der Rohe. From 1940 to 1943 he studied at Harvard, where German emigrants Walter Gropius and Marcel Breuer – whom Johnson had met at the Bauhaus with Mies – had been active since 1937. In 1947, at The Museum of Modern Art, Johnson curated the first Mies van der Rohe retrospective.[9] The exhibition proved a success, and two years later he became Director of the Architecture Department once again. It was in this role that he began redesigning the Sculpture Garden.

The Abby Aldrich Rockefeller Sculpture Garden opened in April 1953. Due to the dialogue between clear spaces and figurative sculptures, the garden's architecture has been repeatedly compared with Mies van der Rohe's Barcelona Pavilion for the 1929 World Fair. However, whereas in Mies's masterpiece the sculpture supports the architectural space, in Johnson's Sculpture Garden the reverse is true – making it an example of successful twentieth-century exhibition architecture.

Johnson designed this "outdoor room" with a windowless, grey brick wall to counter the 54th Street traffic. It was on this wall that Matisse's bas-reliefs could be already seen in 1953, in the same position they now hold in "Figure in the Garden." By contrast, facing from the garden into the museum building or vice versa, continuous glass walls and doors ensure the greatest possible transparency and fluidity between the inner space and the Sculpture Garden. The dialogue between outside and inside, and between two-dimensional artworks and sculptures, is still one of the special features of The Museum of Modern Art. The Sculpture Garden is arranged as an elegant urban park, intended not only as a calming counterbalance to Manhattan's intense urban hustle and bustle but also as a poetic reflection of the city's orthogonal structure.[10] As a sunken garden lying slightly lower than the floor of the surrounding museum, it gives

the observer, immediately upon entering, an overview of the manifold dialogues in which the sculptures are situated. Water and lawn, and trees and bushes ("pseudo-accidental planting areas"[11]), are arranged so as not to conceal the sculptures, which remain visible from almost every standpoint. This means the 1953 garden, which alludes in many ways to the Japanese garden tradition, is clearly distinguished from the initial 1939 design, with its partition walls rising above the sculptures. Instead the central piazza of Vermont marble, the two rectangular ponds, the four other open spaces for exhibiting sculptures, and the two scarcely noticeable raised terraces running along the lateral façades make for a structure that pinpoints the sculptures clearly within the space without separating them visually. This is how Johnson described his project in 1950: "All these measures (the wall on the street, water-channels, bridges) will provide four different areas and backgrounds in which to display various kinds of sculptures. There will be an open central plaza for monumental works, a long narrow plaza, a small square and a large square." In 1953 he wrote in *The New Yorker*, "a roofless room with four subrooms formed by the planting and the canals, to provide four space backgrounds for the sculpture."[12] Realized on a horizontal plane, Johnson's Sculpture Garden is one of the most beautiful examples of Modernist architecture – and, indeed, one that retains its fresh appeal.

To mark the opening of the new Sculpture Garden in April 1953, Director of the Department of Painting and Sculpture Andrew C. Ritchie planned "Sculpture of the Twentieth Century," the first comprehensive overview of the sculpture boom that had followed World War II in both Europe and the USA.[13] Johnson and d'Harnoncourt positioned twelve sculptures in the Sculpture Garden, the remainder in the adjoining exhibition rooms. The central position, currently given to Fritsch's *Figurengruppe* in "Figure in the Garden," was at that time occupied by Picasso's *Homme à l'agneau* (1943–44). This work was not subsequently incorporated into the collection – unlike Picasso's *La Chèvre* (She-Goat, 1950), purchased in 1959 and a hit with the Sculpture Garden's audience ever since. In "Figure in the Garden" it now enters into an interesting dialogue with Alberto Giacometti's *Grande Femme III* (Tall Figure III, 1960), which displays a similar modeling technique. What is used in Picasso's painter's sculpture with playful inconsistency serves in Giacometti's work as a consistent dispersal of the surface, almost to the destruction of the human form in sheer endless vertical linearity.

Interestingly, for the 1953 opening exhibition Johnson and d'Harnoncourt chose only figurative sculptures for the garden, even though "Sculpture in the Twentieth Century" featured many abstract works. This aspect already indicated a latent conflict between the architecture of the garden and non-representational sculpture, more specifically the sculpture of Abstract Expressionism. Later this

Figure in the Garden

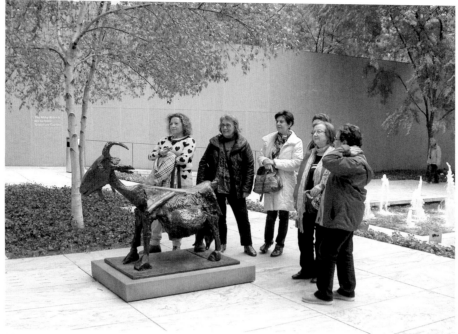

Pablo Picasso, *La Chèvre* (1950)

became more apparent with the installation of a work by Tony Smith – to whom a major retrospective was dedicated in 1998 – and with Minimal Art. Later exhibitions in the Sculpture Garden often featured Smith, the Minimalists, and Alexander Calder, frequently alongside figurative sculpture, although a disharmony was always perceptible. Against this backdrop it is interesting to note that the sculptures of Katharina Fritsch and Tom Otterness harmonize considerably better with this environment of early Modernism.

Also on display at the 1953 opening of the Sculpture Garden, and occupying a similar position in relation to one of the two ponds as it does in "Figure in the Garden," was Aristide Maillol's *La Rivière* (The River, 1938–43), a full-figured nude appearing to tumble into the water. The sculptor died in 1944, at the age of 63, but in 1938 he had begun this work as possibly one of his last encapsulations of the classical form and as a counterpart to his work *The Mountain* (1925), also cast in lead. *La Rivière* is one of the works by Maillol that André Malraux put on show in the Jardin des Tuileries in 1960 to reinvigorate France's museum landscape. Malraux, inspired by the New York Sculpture Garden, was the first French Minister of Culture to make such a move. *La Rivière* was posthumously cast in lead in 1948 and purchased by The Museum of Modern Art the following year.

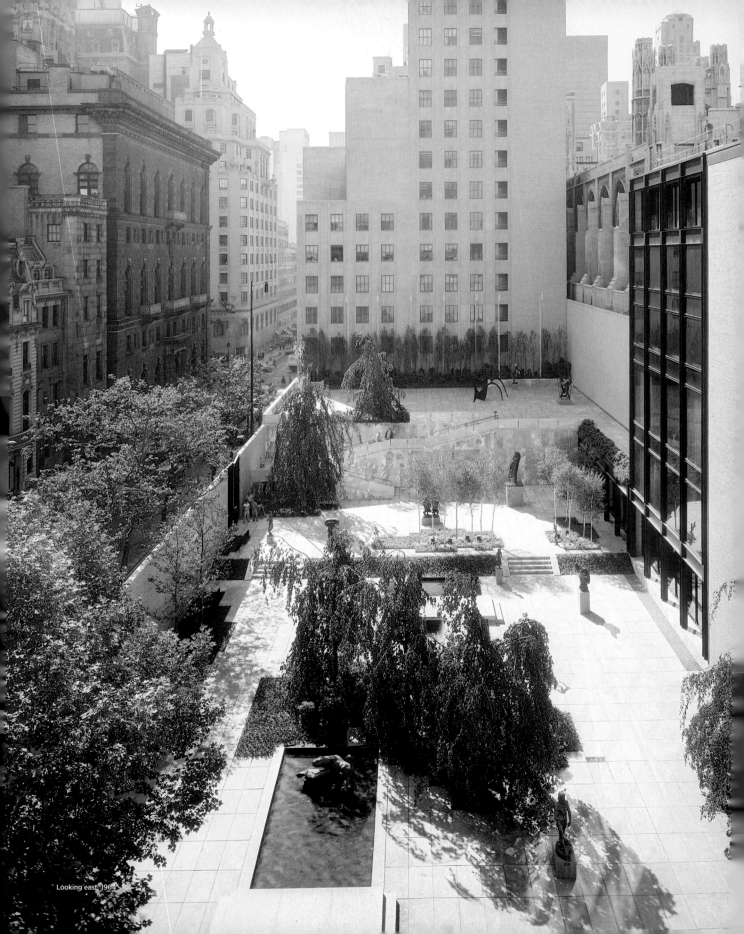

Looking east, 1964

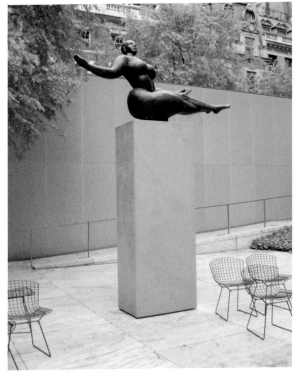

Gaston Lachaise, *Floating Figure* (1927)

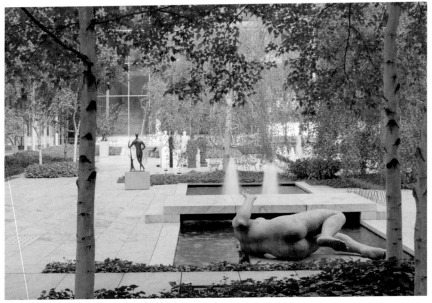

Aristide Maillol, *La Rivière* (1938–43)

In this sculpture today we perceive the urge to express rich corporeality and to highlight an organic relationship to the body – a feature shared by Maillol, Henri Laurens (not included in the exhibition), Matisse, and, to a certain extent, Henry Moore.

Just as spectacular as Maillol's *La Rivière* at the Sculpture Garden's opening exhibition in 1953 was *Floating Figure* (1927) by Gaston Lachaise, one of only three American works to feature in "Figure in the Garden." Born a Frenchman, Lachaise attained immense fame in the US in the first third of the twentieth century. In 1935, the year of his death, The Museum of Modern Art held a retrospective, its first on a sculptor working in the US. *Floating Figure*, purchased in 1937, has been among the Sculpture Garden's most frequently exhibited works.

From 1898 Lachaise studied in Paris, the city of his birth, where he experienced early Modernism and the rivalry between Rodin and Maillol while enjoying renown himself as a young artist. In 1904 he moved with his American girlfriend to New York, where he would become the most successful sculptor of his generation. Central aspects of *Floating Figure* are its search for a new form of corporeality and its use of space to represent movement. The dense focalization of these two aspects in one sculptural form is scarcely found in any other twentieth-century sculpture. At first sight it seems to be a gymnastic exercise. Yet such frank corporeal representation, influenced by the billboard world of American cities, evaded the European sculptural tradition.

Unlike in painting, where the likes of Georgia O'Keeffe and Edward Hopper have reached a wide audience in Europe, American sculpture made before Barnett Newman, Tony Smith, and Minimal Art has still not had a significant European reception. The first major book on Modernist sculpture to appear in Germany after 1945, Eduard Trier's *Moderne Plastik. Von Auguste Rodin bis Marino Marini* (1954), makes no mention of the USA's home-grown sculptural tradition. In his outstanding history of twentieth-century sculpture, Werner Hofmann suggested that in *Floating Figure* Lachaise had created "with his athletic symbols of fertility [...] yet another symbol of the dangerous flattening of humanism into sensualism."[14]

In terms of the history of form, it is interesting to question the role played by *Floating Figure* in the development of American sculpture in the twentieth century. Calder, Smith, Newman, and the Minimalists took radical steps toward a new understanding of sculpture in the wake of the privileged status it had achieved through the efforts of Nadelman and Lachaise. It was scarcely possible to display this expanded concept of sculpture of the 1960s and 1970s in Philip Johnson's Sculpture Garden, though it does impact the current generation, as represented in "Figure in the Garden" by Fritsch and Otterness.

In anticipating an inorganic concept of design no longer oriented around the use of real bodies as models but instead concerned with the advertisement images that had already begun to characterize the New York cityscape in the first half of the twentieth century, this North American tradition has a surprisingly great deal to do with current issues in sculpture. The monumentalizing self-importance and hyperrealism of Lachaise's female figures lead via underground tracks, as it were, to Claes Oldenburg's "soft sculptures." In the New York of 1963, Oldenburg's work traced yet another new path away from the European-influenced sculpture of the first half of the twentieth century and would become pivotal for Fritsch's and Otterness's ideas about sculpture.

What is particularly revealing in "Figure in the Garden" is the immediate vicinity between Lachaise's figure and Maillol's full-bodied nude, *La Rivière*. In his day, Maillol was celebrated in France as the most important twentieth-century sculptor. He may well have been countering Lachaise's then very famous *Floating Figure* with an equally extreme gesture – one that both brings the representation of movement to a head and affirms the neo-classical ideal over the stylization and object quality of Lachaise's work. Just as evident here is also the theme of fertile woman's return and reconciliation with water and nature, and an ensuing "organic" notion of society. In the year the work was completed, this very much reflected the ideology of the Vichy regime; the sculpture conveyed the idea that these political ideas were not to be seen as a reactionary step backward but as a way to supplant a Modernism perceived as decadent, which Maillol saw embodied in Rodin's hypersensitivity.

The pivotal themes of twentieth-century figurative sculpture – movement, an organic concept of the body, and the dynamic relationship of sculpture and space – can also be seen in the early examples of American sculpture featured in "Figure in the Garden." *Man in the Open Air,* made in 1915 by Elie Nadelman, gives expression to movement and the biological by means of its *contrapposto* pose and fine-jointed lines emphasizing the vertical – an emphasis that to a certain extent anticipates Giacometti's late sculpture, such as *Grande Femme III*, also on display in the exhibition. A comparison of the two sculptures reveals Giacometti's figure as a product of decades spent trying to define an idea of the figure, as opposed to the traditional function of representation. This, alongside his intensification of the relationship between figure and space, is what distinguishes the reach of his work.

Nadelman's sculpture was produced forty-five years before Giacometti's piece and conveys the spirit of new artistic beginnings. In 1915 New York was still reeling from the impact of the 1913 Armory Show, the first comprehensive exhibition of Modernist art in the US, just one year on from a landmark exhibition of

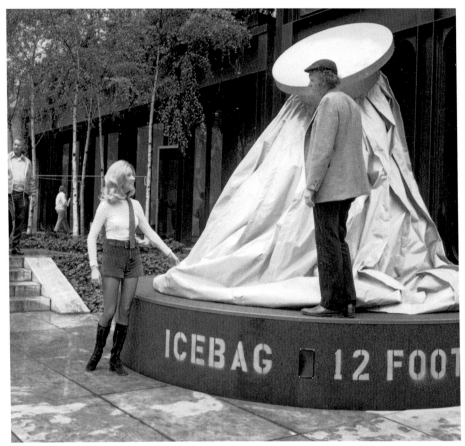

Claes Oldenburg installing *Ice Bag, Scale C* as part of "Technics and Creativity: Selections from Gemini G.E.L.," 1971

European Modernism, the Cologne "Sonderbund Exhibition." Previously, several generations of American art students had studied in Europe and gone on to develop the circles of collectors and museum founders in the USA that would play a significant role in shaping twentieth-century museum history. The founding of The Museum of Modern Art was part of this cultural transfer, which had begun in the mid-nineteenth century.

In 1902, at the age of twenty, Eliasz Nadelman moved from his hometown of Warsaw, then still part of the Czarist Empire, to Munich. Two years later he moved to Paris, where in 1909 he was exhibited as a major talent at the influential Galerie Druet, was collected by Leo Stein, and created some key early examples of Cubist sculpture. After the outbreak of World War I he moved to New York, like Marcel Duchamp, to avoid military service. *Man in the Open*

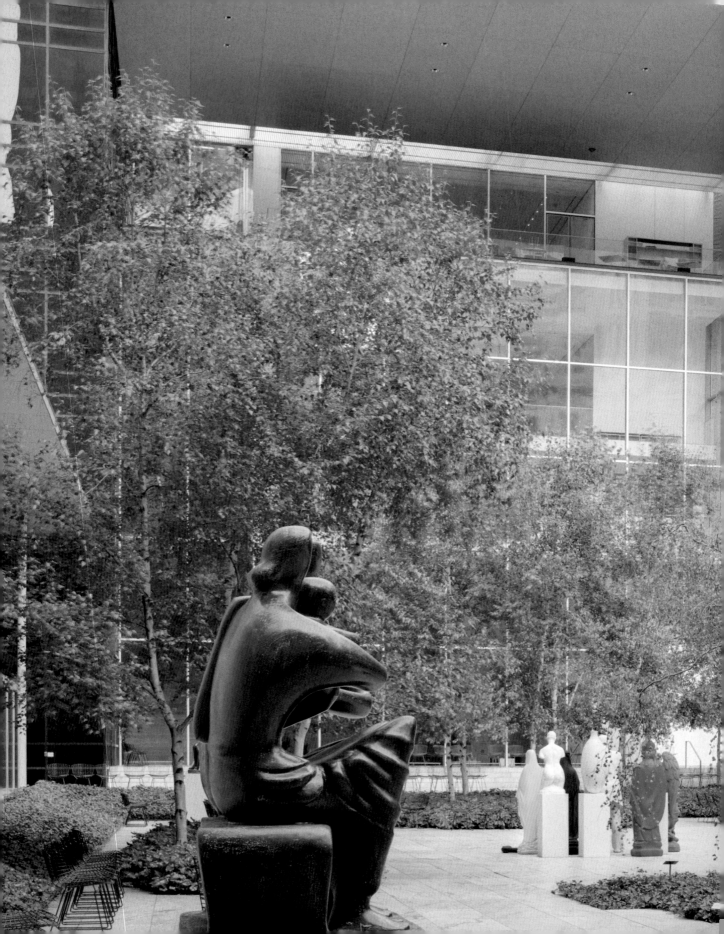

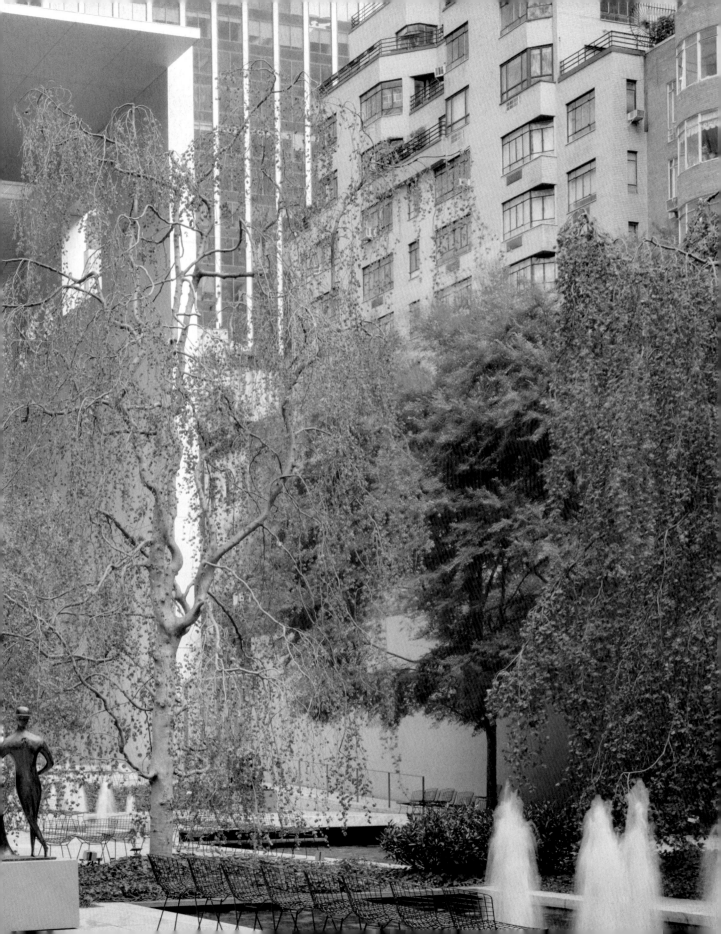

Air (c. 1915) was his first great success in his adopted homeland. He managed to condense the European avant-garde, from Art Nouveau through to the dissolution of the monument, into a realistic form. By linking an abstract male figure with a modern hat and street scene, he opened up a sculptural repertoire that paved the way for the themes of early twentieth-century North American art: everyday life and a sense of realism anchored in local artistic traditions. In 1948, two years after his death, The Museum of Modern Art held a Nadelman retrospective, which later traveled to museums in Boston and Baltimore.[15]

One of the strengths of Museum of Modern Art's collection, developed without interruption since the 1930s, is its ability to trigger surprising dialogues. Nadelman's artificial-looking *Man in the Open Air* very much interested both Fritsch and Otterness in "Figure in the Garden." Otterness explored in depth Nadelman's ideas and career, his first major Folk and Outsider Art collection in the USA, and his early attempt to derive a non-European sculpture tradition from local traditions. In many ways Nadelman was a pioneer of the far-reaching simplifications that swept American art after 1945. However, for Fritsch this sculpture by Nadelman – alongside its neighbors by Maillol and Matisse, as well as Sintenis's *Daphne* – is among those works that come closest to her own in "Figure in the Garden." *Man in the Open Air* is an Art Nouveau figure that has almost advanced to Pop art, one that very early on seems to embody a non-organic notion of the body.

Compared with the proud optimism of Nadelman's and Lachaise's work, those testimonies to the period after World War II in "Figure in the Garden" are marked by a skepticism about the possibilities of representing the human image in sculpture. In the middle of the twentieth century Henry Moore's vision of sculpture was arguably pivotal. *Family Group* (1948–49) displays a feature that was to become characteristic for all the figurative works in the exhibition produced between 1945 and 1988. Unlike any of the sculptures on display from the pre-war period, none of these figures have specific faces. Faces are replaced by a surface or sign. Moore's *Family Group* deals with humanity's existential self-questioning and the reestablishment of interpersonal ties after the catastrophe of World War II – with the spatial dynamics of the sculpture developing somewhat inwardly, as the three figures seek to turn toward each other. This sculpture is the only multi-figure work in the exhibition apart from Fritsch's *Figurengruppe* and the only other work to feature male and female figures.

Throughout his life Max Ernst saw sculpting as a way to take a break from painting. His sculptures convey this, and his casual approach to the medium has also had considerable impact on modern-day sculpture. In the context of this exhibition, Ernst's *The King Playing with the Queen* strikes a different tone.

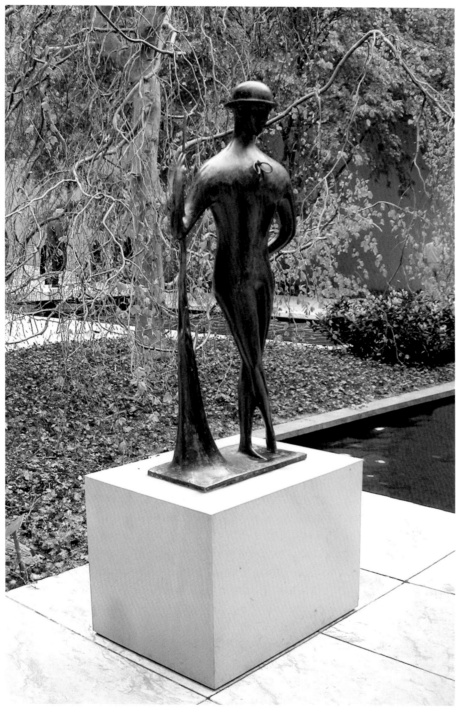

Elie Nadelman, *Man in the Open Air* (c. 1915)

It was produced in 1944, when the artist was living in the US and in close contact with the passionate chess player Marcel Duchamp. Ernst's figurative bronze sculpture is arranged like a game of chess whose players are the chess pieces themselves. The confident pose of the king, who is contrived as being influenced by Native American mythology, contrasts with the earlier works. A slight twist in the upper body is enough to flip the two-dimensional surface into three dimensions and define the space between the players in a dynamic way. A dispassionate leaning movement from the king to the queen locates this work between the static *Figurengruppe* in the middle of the garden and the clearly animated *Saint Jean Baptiste prêchant* on the western edge. The figure was fashioned out of everyday items, such as drinking cups, auto parts, and the like, before being sculpted and cast. This is what gives the sculpture its freshness, its anticipation of the use of everyday objects in sculpture, painting, and object art from the 1950s.

Appearing as a counter to Ernst's sculpture from the Surrealist movement, Joan Miró's *Oiseau lunaire* (Moonbird, 1966) is the second-tallest sculpture in the exhibition, after Giacometti's *Grande Femme, III*, and the most voluminous. As a painter's sculpture, this work also adopts a free and playful approach to the sculptural repertoire and thus finds its way to an understanding of body and volume that differs considerably from those in Maillol and Moore. Despite – or perhaps because of – its great volume (which does not, however, make it monumental), *Oiseau lunaire* looks like an imagined object that, unhooked from imitations of nature, displays numerous layers of interpretation. Like Moore and Ernst, with *Oiseau lunaire* Miró sought an updated approach to the formal, mythological, and ritual potential of sculpture's early history, which gave sculpture an independent role in the increasingly integrated world of post-war consumer society.

Ernst lived and worked until 1976, Miró until 1983, and Moore until 1986. Against this backdrop the apparently époque-breaking shift from classic Modernism to contemporary art proves more blurred. This is also the case with Tom Otterness's *Head* (1988–89), produced as part of a multi-piece sculpture for Manhattan's Battery Park. As with Otterness's other works, it is not based on a specific head but on a general notion of the head, modeled freely and subsequently enlarged. The early Modernist move away from the organic notion of the body already intimated by Moore, Ernst, and Miró is here brought to its logical conclusion. Although seeming to sleep, Otterness's *Head* is consciously arranged as an artistic form rather than a living organism. The external form is not an expression of inner organs and movement but an image, sign, or organless body that can display disparate feelings and emotions. This non-organic notion of the body also characterizes Katharina Fritsch's nine figures.

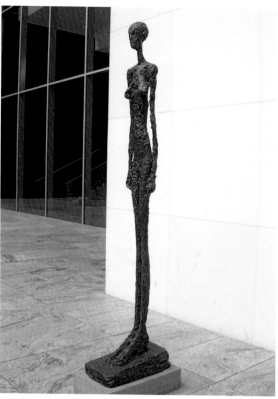

Alberto Giacometti, *Grande Femme III* (1960)

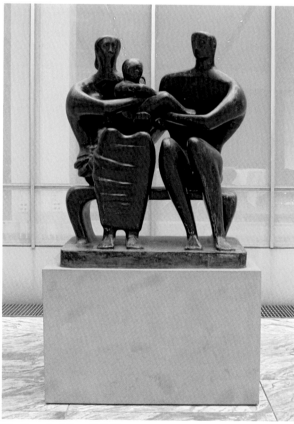

Henry Moore, *Family Group* (1948–49)

Otterness's sculpture is part of an ensemble through which a human figure's extremities seem to emerge out of the ground in Battery Park. In his early work inspired by Minimal Art, Otterness made a leap from the verticality of traditional sculpture to the horizontal – the same leap that from the 1960s transformed the paradigms of sculpture with Minimal and Land Art. What also becomes clear here is the social occasion and meaning of the sculpture as it encounters an audience of passersby in the park, most of whom do not react with an eye trained to read artistic ideas. In this respect, it is of particular significance that due to a number of formal qualities *Head* can be understood as the head of an African-American – yet this reading is blurred by the colorlessness of the bronze. Its spatial proximity to Maillol's *La Méditerranée* in the Sculpture Garden demonstrates two different applications of an emphatically classical form that in the Otterness does not signal an affiliation to classical art but is merely retained to reinforce the sculpture's solemnity. In the isolated presentation of the head in "Figure in the Garden," a decision that involved the artist, the sculpture seems like a gravestone for an unknown fellow citizen.

Within this multifaceted dialogue spanning 130 years of figurative sculpture, Fritsch's *Figurengruppe* emerges even more clearly as a key sculptural work of the last few years. The group is clearly composed. Each figure has an intensity, whichever angle it is viewed from. Furthermore, the group is arranged so that it appears equally balanced from all sides. Alongside this classical conception of sculpture, it also relates to the sculptural tradition through its strong revision, through modeling, of raw forms. Since her first sculptural works in 1979, Fritsch has consciously taken her cue from existing forms in order to achieve an image-like quality in sculpture. Consequently, the individual figures in the group are taken from human models and *objets trouvés*, sometimes using plaster casts and sometimes with the help of a 3-D scanning process that until a few years ago was available only for industrial uses. This results in an inorganic notion of the body; figures are no longer developed through modeling but are initially produced as objects. They subsequently undergo a modeling treatment, however, as this is not about placing an object in an art context by reproducing or enlarging it as a ready-made. It is about creating three-dimensional images using motifs based on fleeting childhood memories and related to the collective unconscious, to the emotions of the individual, without being a sign or symbol of something or a fragment from contemporary media.

In the exhibition, *Figurengruppe* stands out with its many multicolored, radiant yet matte tones that give the sculptures their indefinable outward form. Fritsch already produced colorful objects as early as her student years. A key work here was the first *Madonna* from 1982, a souvenir object painted yellow. *Figuren-*

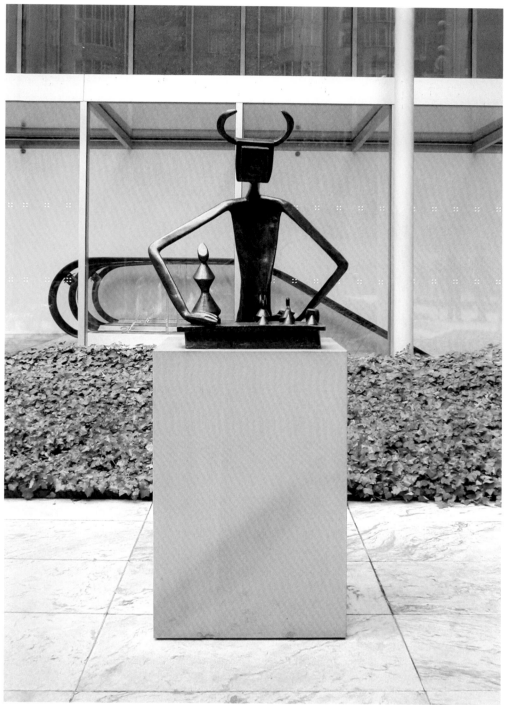

Max Ernst, *The King Playing with the Queen* (1944)

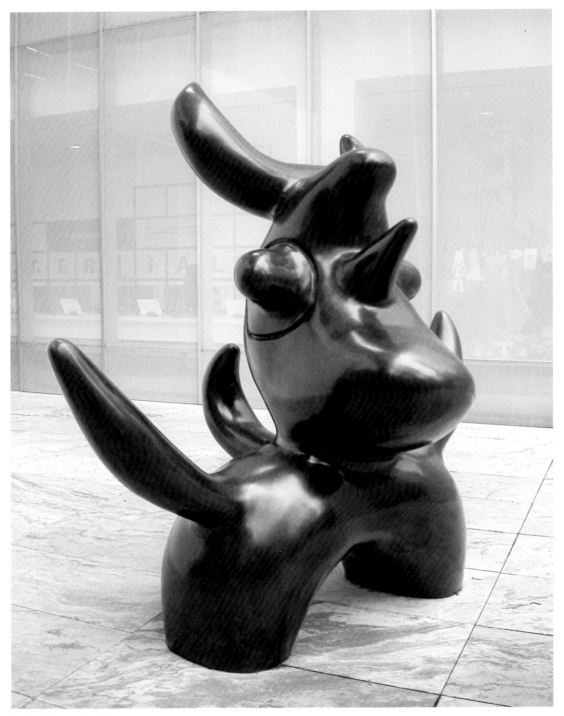

Joan Miró, *Oiseau lunaire* (1966)

Figure in the Garden

gruppe emerged in Fritsch's Düsseldorf studio out of an idea for a new, complex sculpture consisting of several figures produced in several different contexts. The choice of colors for the individual figures was not random. Alongside composition and the decision to produce all figures to the same scale, color choice constituted a key procedure in the genesis of *Figurengruppe*.

The flawless matte finish in particularly pure colors rejects the light surrounding the figures, making them appear unreal. It is on this and on the irresolvable contradictions of the figures that the sculptural ambiguity and open spectrum of *Figurengruppe* rests. The unreal manifestation of figures that are at the same time very present and the inorganic approach to the body give expression to essential present-day experiences.

Endnotes

1 See Susan Sontag, *Against Interpretation and Other Essays* (1966), Picador USA, New York, 2001, pp. 263–74

2 See Werner Hofmann, *Das Atelier. Courbets Jahrhundertbild*, Munich, 2010.

3 See Alfred H. Barr, Jr. (ed.), *Painting and Sculpture in The Museum of Modern Art*, The Museum of Modern Art, New York, 1948, pp. 248, 321, 325.

4 *Renée Sintenis. Mit Beiträgen von Rudolf Hagelstange, Carl Georg Heise, Paul Appel*, Berlin, 1947. *Daphne* appears in two good illustrations in Figures 84 and 85.

5 Alfred H. Barr, Jr., *Matisse: His Art and His Public*, The Museum of Modern Art, New York, 1951.

6 Alfred H. Barr, Jr., *Picasso: Fifty Years of His Art*, The Museum of Modern Art, New York, 1946.

7 On the creation and architectural program of the garden here, I follow the outstanding study by Mirka Beneš, "A Modern Classic. The Abby Aldrich Rockefeller Sculpture Garden," in *Philip Johnson and The Museum of Modern Art: Studies in Modern Art 6*, New York, 1998, pp. 105–51.

8 Barr, quoted in Beneš, ibid, p. 116.

9 This exhibition, titled "Mies van der Rohe," was on view from September 16, 1947, to January 25, 1948. Today The Museum of Modern Art is home to the Mies van der Rohe Archive.

10 When Johnson showed him the model of the Sculpture Garden, the major architecture and art critic Siegfrid Giedion is said to have shouted out, "At last, a piazza in New York!" Quoted in Beneš, op. cit., p. 137.

11 Philip Johnson, quoted in ibid. p. 128.

12 Philip Johnson, quoted in ibid. pp. 126, 132.

13 See Werner Hofmann, *Plastik im 20. Jahrhundert*, Frankfurt am Main, 1958. The subsequently widely distributed book was largely written in the library of The Museum of Modern Art. See Robert Fleck, *Werner Hofmann – Ein Gespräch*, Hamburg (not yet published).

14 Hofmann, ibid, p. 61, translated from the German by Claire Cahm.

15 Lincoln Kirstein, *The Sculpture of Elie Nadelman*, exhib. cat., The Museum of Modern Art, New York/Institute of Contemporary Art, Boston/Baltimore Museum of Art, 1948.

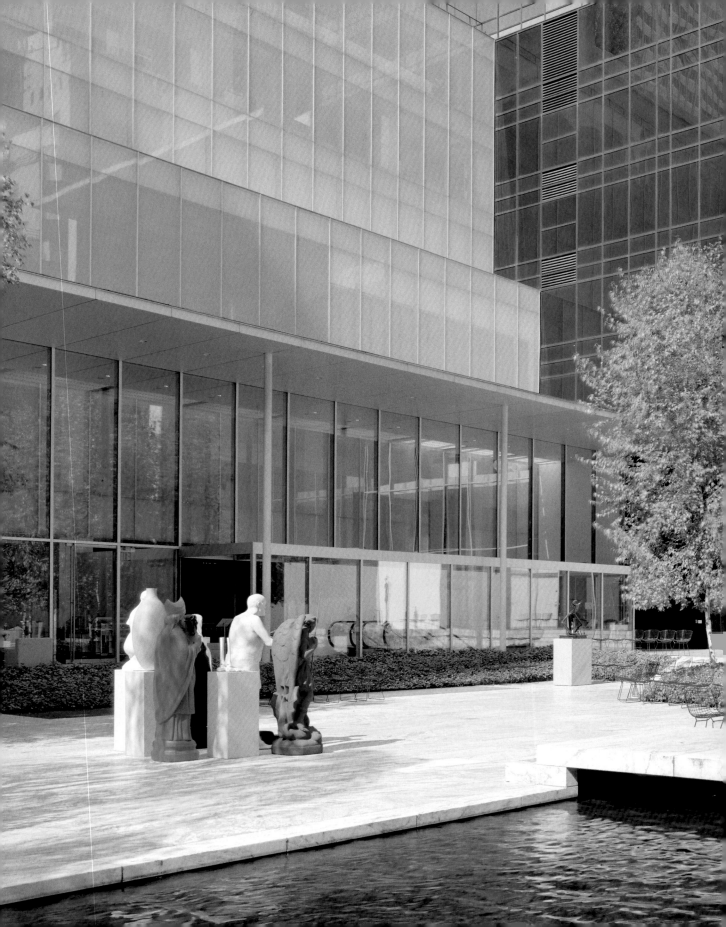

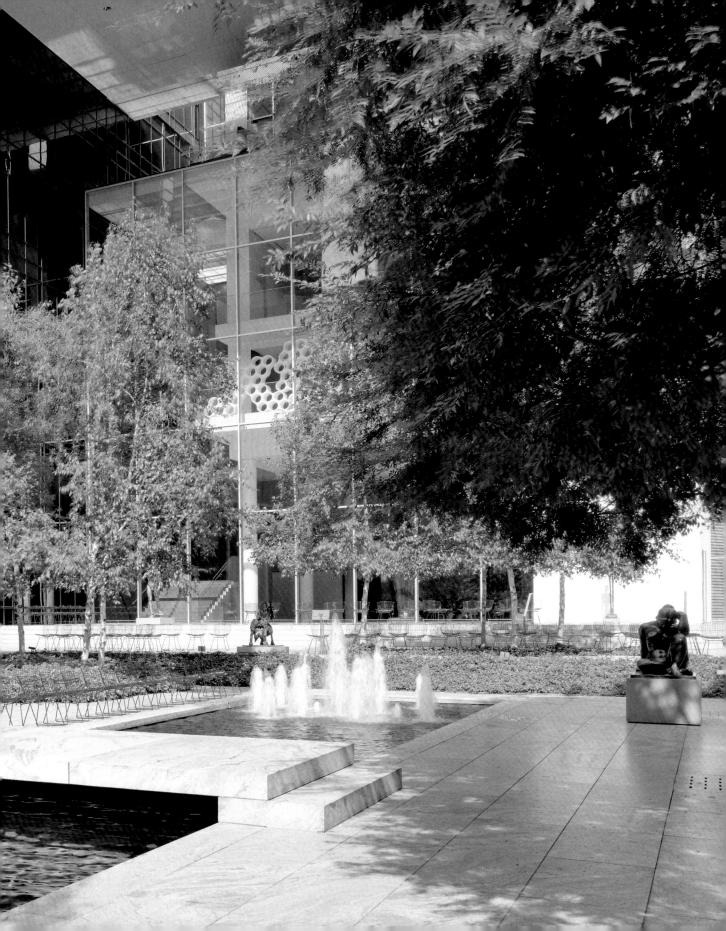

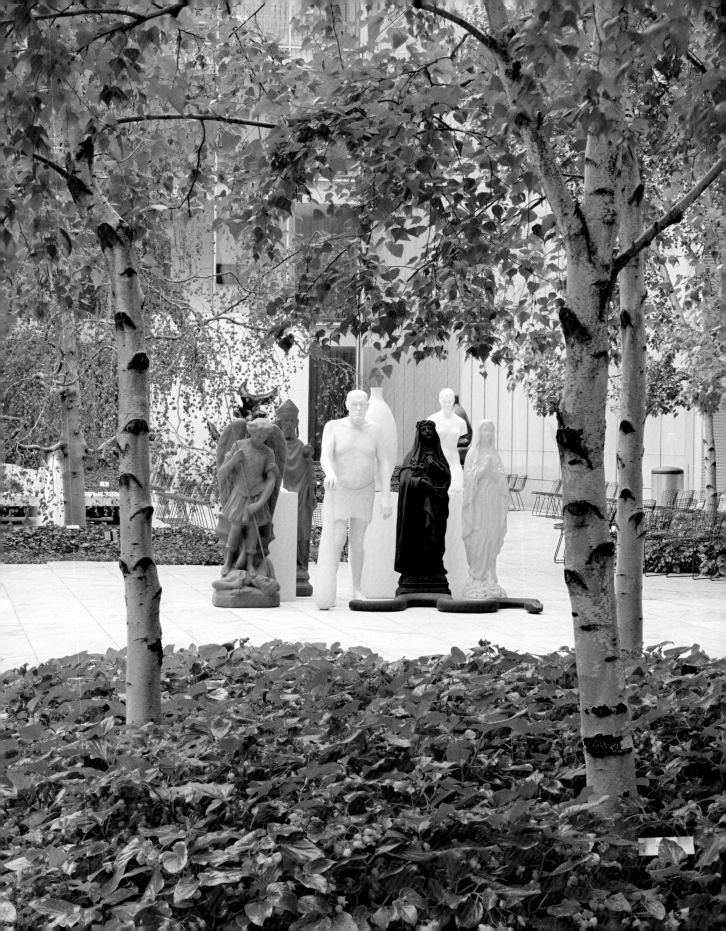

Conversation at MoMA

Tom Otterness: Were you thinking of Rodin's *Bourgeois de Calais* (Burghers of Calais, 1884–95) when you made the work that's here in the Sculpture Garden?

Katharina Fritsch: I thought about putting sculptures together like they were standing together in storage, or just before entering storage. And suddenly I wanted to make a composition out of that idea. It is always a little bit of a story in my head, but it is playful. I like to be playful with my sculptures.

Ann Temkin: Our visitors are absolutely fascinated by your central piece here in the exhibition.

KF: People are mostly attracted by the colors. When you make an abstract sculpture in bronze, people don't stand so long in front of it. And people like groups of figures. I watched this happen in Basel with the Rodin group. People love it when there is more than one character. And my group is also a funny combination, something never seen. There is a holy figure and beside him just a normal man.

TO: The big guy – who is he?

KF: That is a taxi driver in Düsseldorf, a nice man. I entered his taxi and saw this face. He had a disease – he could not stop growing and had edema on his foot. It is a little bit of a meta-sculpture. In our generation, we cannot make a figure like Rodin, because we have another idea of the body. During the 1980s, disease was again a big theme, because of AIDS. This changed our relationship to the body – we did

not have any more confidence in it. There was no longer the same belief in the body as there was in Rodin's time.

TO: Sometimes I think your piece is like a Hollywood set where different movies are being made but all the characters have taken a break. They are off duty but they are in their costumes, walking around.

KF: That's true!

TO: We can see it this way. Oh, Jesus has wandered over, having a cup of coffee with –

KF: Yes, like this – it is really coming down to earth.

AT: A friend who has a son in high school showed me what the boy had chosen for the screensaver on his computer: an image of your piece. He had no idea that it was at MoMA. Out of billions of images in the world, this high school boy, who knows nothing about art, finds this for his screensaver!

TO: That's public art! It used to be that people would take photos in front of your sculpture and it might make it into a family album. Of course, now it's on Flickr, out in the world, so it becomes very public. But it comes from a personal beginning – standing next to Katharina's piece here at MoMA and getting your photo taken.

Robert Fleck: Ann, what was the origin of the "Figure in the Garden" exhibition?

AT: When I took this position, I decided that there should be an annual presentation in the Garden instead of a permanent display or slightly changing display, and that it should have a theme each time. We called the first one "Sculpture in Color," because we had just acquired three brightly colored works by Franz West. We looked for every piece we had in the collection that was in color – which did not yet include Fritsch. We followed that with "From Line to Plane." I think we considered the idea of the figure once we knew we would acquire the Fritsch works. And it took a year – do you remember? Longer than we thought. So we originally planned "Figure in the Garden" for when we thought your pieces would be ready. And then, when we learned that your work would not be ready, we came up with "From Line to Plane" in about a week. "Figure in the Garden" was occasioned by the arrival – or the expected arrival – of Fritsch's *Figurengruppe*. That's exactly right. We realized that there would be an opportunity to make a thought-provoking presentation. I mean, to do "Figure in the Garden" without a twist would not have been so interesting. But with the twist – to bring it up to the present – it felt interesting.

RF: It is very interesting that you are starting with the present, with sculptures of this new century, and then you go back through history using the MoMA collection. The relationship is quite different. Your final point is Rodin. This is about 130 years in the history of sculpture. The tradition of Minimal sculpture is much shorter, of course. Did you choose the older "figures" in relation to the contemporary pieces by Tom and Katharina?

AT: Not in a systematic way, but in an intuitive way – as if we were playing dolls on this table. We had photographs of the potential candidates. Then we started to ask which ones would be more interesting together. We narrowed it down. Finally we made the choice. The idea was, "Which works would talk among themselves the most?" It was about making older sculptures in the collection partner with these new works.

RF: At its inauguration in 1939, the Sculpture Garden was a first for a modern art museum, but it was conceived as part of the exhibition "Art of Our Time" – certainly the best exhibition about modern art in the first half of the last century. Later on, and also today, it was always linked to an exhibition. The Sculpture Garden at MoMA has never been a static thing.

AT: They thought of it as a room, as a gallery — not as a garden.

RF: A "roofless gallery."

AT: At the beginning, in 1939, when this building opened, it was a more amorphous space, loosely modeled on the forms of Arp. Only fourteen years later, in 1953, did Philip Johnson gave it this geometry.

KF: The rectangular architecture of the Sculpture Garden is very fitting for figurative sculpture. It gives more tension. If you put Minimal Art in this context, it gets repetitive.

RF: Philip Johnson was influenced by Mies van der Rohe's 1934 Barcelona Pavilion, in which figurative sculpture is placed in opposition to abstract surfaces. The sculptures serve the architecture. Whereas Johnson conceived the MoMA Sculpture Garden to reinforce the independence of the sculptures. Architecture serves the sculptures, which is rare.

TO: The Garden itself became so abstract in his design. Nature is abstracted, or contained, while the human sculptures roam free. It's a strange kind of blend.

RF: The sculptures in the exhibition are very much talking with each other. The Max Ernst bronze is in dialogue with the instability and potential movement of Rodin's *Saint Jean Baptiste prêchant* (St. John the Baptist Preaching, 1878–80). The small legs of the

Picasso correspond to the legs of the big male portrait by Giacometti. There are also interesting rediscoveries in the exhibition, like Renée Sintenis, a female German sculptor.

AT: We rediscovered this work – which one might call both abstract and figurative – in our collection. The sculpture was often displayed in the Garden since 1953.

RF: When Alfred Barr and Philip Johnson were traveling in Europe in order to conceive The Museum of Modern Art, in the 1920s, Renée Sintenis was the second woman sculptor to be elected to the Academy in Berlin, after Käthe Kollwitz.

KF: Sintenis is known in Germany, among a small group of collectors, for her animal bronzes. Later in life she designed the Berlin bear.

RF: Many works that have more or less disappeared in Europe are still in MoMA's collection. In the exhibition, there are only two woman artists, which is quite emblematic of the history of sculpture. There are not so many bronze sculptures by women.

AT: Women were turning more to alternative mediums like photography and, later, video. I think they felt freer to dig into the new media because there was not the same dominating male tradition. But there actually may be a history of female authors of sculpture in modern art that we don't know. Perhaps many of them never went beyond the stage of clay, plaster, or wax. I don't think I can name another woman artist, other than Sintenis, who was working through a personal interpretation of Modernism, in bronze, in the early twentieth century.

KF: It is hard to do sculpture. It is an ambitious way to make an artwork. You can never work alone, and you have to deal with so many partners. And you have to deal with reality a lot, with the circumstances of materials and techniques.

TO: It's like making movies. You have to work with other people. You have a production crew and you have to have backers. And once it gets made, you need a place for it. You can't roll it up like you can with canvases.

KF: Of course, figurative sculpture, over the years, was considered a "no go." It was considered politically incorrect. But Tom and I are really risking popularity by being realistic in our sculpture. I think that is the hardest thing you can do, because you have to work along a very fine line. I like to be popular, not populist.

RF: There is only one American-born artist in the show: Tom Otterness. Gaston Lachaise, born French, lived in New York and had a solo exhibition

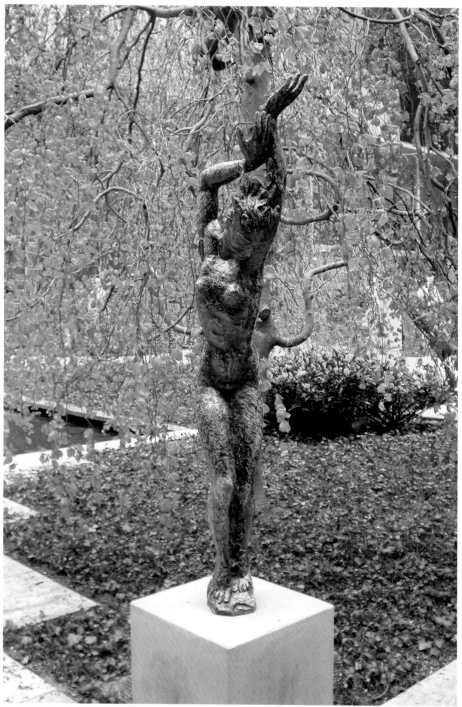

Renée Sintenis, *Daphne* (1930)

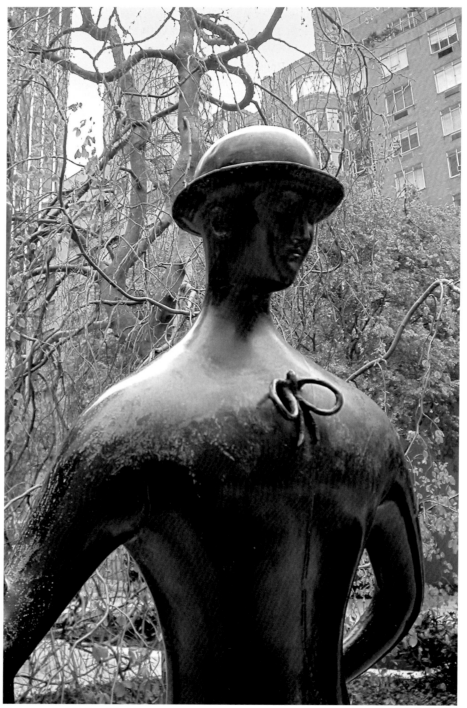

Elie Nadelman, *Man in the Open Air* (c. 1915)

at MoMA in 1935. His sculptures have often been exhibited in the Sculpture Garden, along with Picasso's *La Chèvre* (1935). Elie Nadelman, born in Poland, also became a US citizen.

AT: Nadelman occupies a very American position in this exhibition. He was one of the first professional artists thinking about what today we would call self-taught artists. In that sense, in the US it was also partly a patriotic interest – celebrating our vernacular traditions. I think we still have this Modernist inheritance.

RF: It is rooted in a very different tradition compared to the European history of sculpture.

TO: Nadelman's life is fascinating. He worked for and was part of the wealthy class up until the crash. Then he lost everything and he worked for twenty years with almost nothing.

KF: He was a discovery for me.

RF: Tom, how did you get into your sculptural work?

TO: First I made two-dimensional signs out on the street, international sign symbols. I bumped those into 3-D and started making "souvenirs." I wanted to make the sculpture big but I could only afford the smaller version. So you would buy the souvenir, and the real sculpture never existed. Some were very figurative, very Rodin-ish – a man wrestling with an angel or fucking an angel, a little monument.

KF: You did the merchandising before they became bronze?

TO: Yes. I cast them myself in plaster and sold them for $4.99, out on a blanket in front of MoMA. I had them in the souvenir shop of the "Times Square Show" on 42nd Street and at other Colab stores around the city. Eventually this led to making public work in bronze.

KF: Who else is able to do a frog inside a schoolyard like Tom did? To walk this fine line, that is the thing – to make something that works and does not become kitsch. That is what I also like to do.

TO: It's a serious danger to work in the public sphere. You have so many forces, pushing you one way or the other, that you risk falling into that abyss of kitsch.

RF: An interesting parallel between your two pieces is that they are both about emotion. Pure emotion – not emotion as an affect, à la Deleuze.

KF: We are both unafraid of emotions.

TO: But I love the Minimalists, too.

KF: Me too. I totally admired Donald Judd, for example. Also the colors in his work.

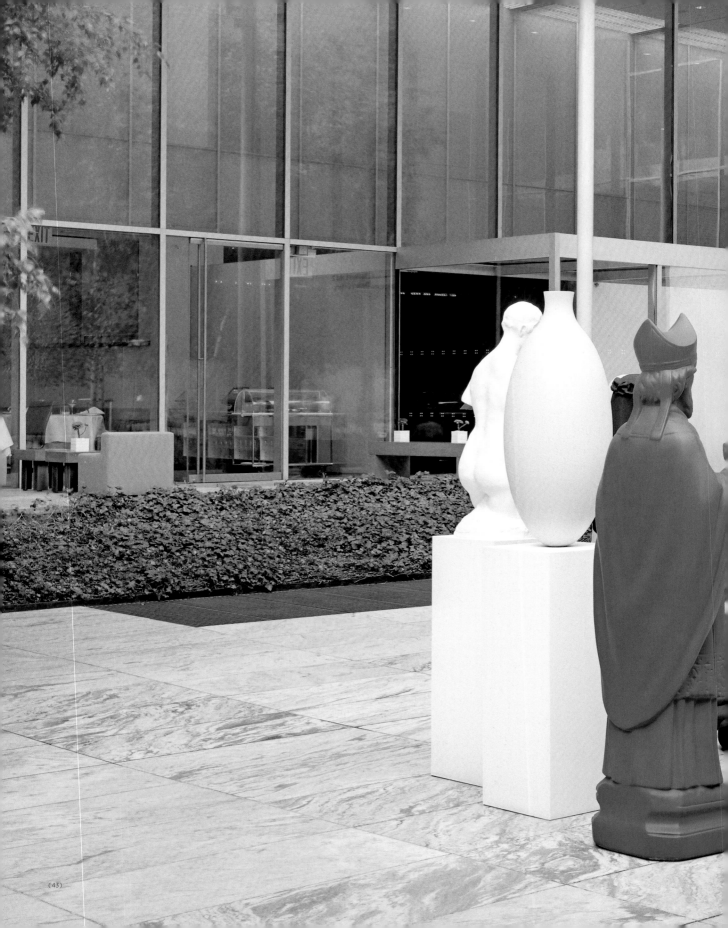

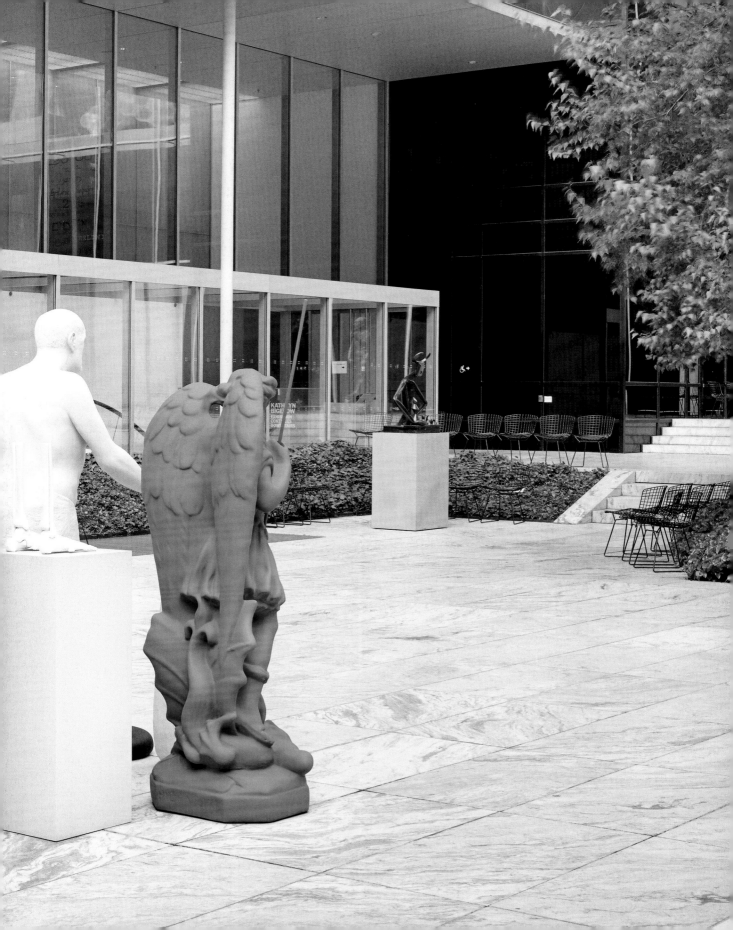

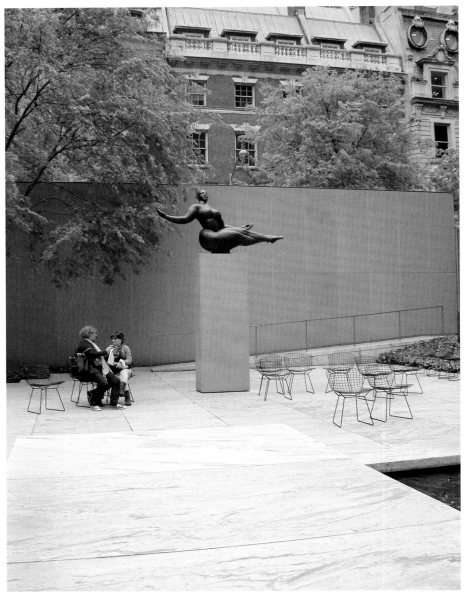

Gaston Lachaise, *Floating Figure* (1927)

TO: Regularity. Formalism.

KF: But is life like that? I am another character. Weren't we both referring to Claes Oldenburg's work?

TO: Yes, I remember having seen Oldenburg once on the street in SoHo, as a student. I didn't know what to do. So I just followed him for blocks and blocks. I was too shy to say hello.

AT: You voted with your feet!

RF: At the first Skulptur Projekte exhibition in Münster, in 1977, there was Oldenburg's *Three Balls*. The way Oldenburg managed to place this artwork in the public sphere remains an example forever.

KF: I was a young student there, and I made watercolors of them. Oldenburg thought a lot about form. He also added colors. He worked with things that existed – he blew them up. That is also how I proceed. It is really about sculpting.

Fleck: Wouldn't Oldenburg be the missing link between historical sculptures and your contemporary works?

KF: I think so. My teacher in Düsseldorf, Fritz Schwegler, was the missing link between Oldenburg and Beuys.

AT: In your mind, is it a problem if people touch your sculpture?

TO: No. Touching sculptures is part of having work in public.

AT: Is it a problem if the bronze patina gets rubbed off?

TO: For me, it's a kind of democracy. It shows people's favorite things. I worked in Italy when I did my first bronze. I saw a small sculpture there that had been completely worn away from hundreds of years of touching.

RF: Thousands of people must have touched that sculpture.

AT: Over centuries.

TO: My first piece in the Garden, a bronze sculpture, was about touch. Visitors could sit at these tables. They were not allowed to bring food into the museum, and they could not touch the other pieces in the Garden, but they could sit on and touch my work.

KF: I would like to push my work to a point where the sculptures can be touched. I would like it if, from time to time, they could be washed like a car. In this regard, I am getting more and more into colors that are really industrial products. Now, instead of wax, I use a material that is used for airplanes. I don't want to be "untouchable." Sometimes people misunderstand my work – "She is such a perfectionist." But I am only a perfectionist because the work has to

reach a point where it turns into this kind of virtual thing, or something that is really strange outside.

RF: Ann, by organizing your exhibition around two contemporary pieces, you have placed a big question mark on the history of figurative sculpture.

AT: Part of what has interested me since being here at MoMA is repopulating the Sculpture Garden with art made within the last thirty years. I don't want the Garden to be a period piece about the moment in which it was constructed – which could be one approach, of course. For me, the Garden is strong enough to support important contemporary work. Just as it supports much earlier work that had nothing to do with the aesthetic of mid-century sculpture; we had not only Maillol, Lehmbruck, and Rodin but also Renoir and other late-nineteenth-century sculptures in the garden, and it accommodated them beautifully. For that reason, I don't think it has to be sculpture of the 1950s that is synonymous with the Garden. I want to update it with twenty-first-century sculptures.

RF: But are you continuing to organize the Sculpture Garden through exhibitions?

AT: There never was a defined policy for the Sculpture Garden. Similar to the indoor collection galleries, my practice is one of ongoing flux. That is currently the only way, in the space we have, that we can do justice to the diversity of the collection. This is a change from the attitude we inherited, which is that you could go to a museum and always go to such-and-such wall and find that thing that you love. There would be a sense of permanence about what was on the walls or on the floor. And similarly, in the Garden, for many years that was more or less what you saw – the *La Chèvre* here and the Lachaise there, etc. Although I appreciate that scenario, today we cannot afford it. And so instead I have to look on the bright side and say, OK, maybe we are sacrificing the old museum experience – returning to your favorite thing in the exact spot – but we can replace it with the phenomenon of being surprised every time you come and knowing that you can learn something new every time. Over the course of many visits, what you will have actually experienced is so much wider and deeper than if we were always just showing the top ten hits, or top one hundred hits. I have extended that philosophy to the Sculpture Garden. Every time we reinstall, there are new stars – somebody who is a supporting actor can become the lead, or somebody who was not even an extra is suddenly on stage. That said, there are a few things in the galleries – like Van Gogh's *De Sterrennacht* (The Starry Night) – that if we took them off the wall my office would be mobbed with protesters. And there are a handful of things like that in

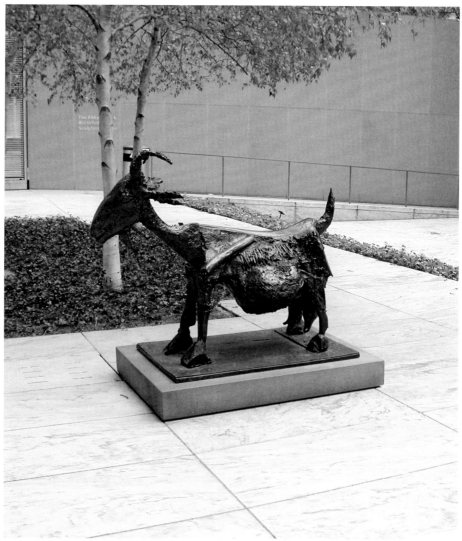

Pablo Picasso, *La Chèvre* (1950)

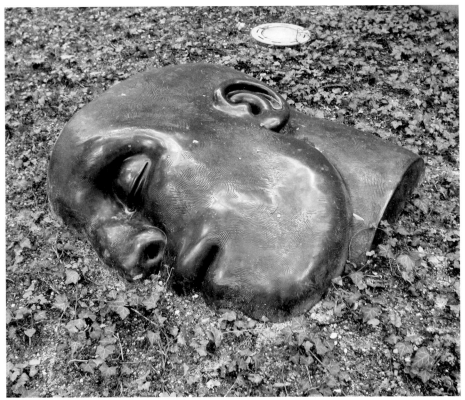

Tom Otterness, *Head* (1988–89)

the Sculpture Garden – probably the *La Chèvre*. But, for sure, there are things that may once have been considered impossible to remove that you are not always seeing anymore with these changing displays.

RF: This is also the freedom of this new century. Because there is no kind of dogma.

AT: That's the message.

KF: The Garden has a good scale. It has incredibly good proportions, which makes it attractive for sculpture.

TO: It is scaled for humans. And for figurative sculptures.

RF: You are defining the museum and the Sculpture Garden as two parallels in flux. Probably flux is so much in our daily lives that people would find it boring to see the same display again and again at MoMA. But with this method of changing the displays, you also create new relationships between the artworks. You can question the history of modern sculpture. In 1958, Werner Hofmann, one of the most respected German-speaking art historians from the middle of

the twentieth century, published a book called *Plastik im 20. Jahrhundert* (Sculpture in the 20th Century), which he wrote here at MoMA while he was a lecturer at Columbia. The book has sold more than 120,000 copies. He insists that sculpture has been an experimental medium since Rodin.

KF: I think it still is it – especially when I think about how much I am dealing with technical issues and materials. For the new outdoor things, I am doing more bronze. But I am also working with 3-D renderings, for example, to blow things up and rework them.

AT: The intersection with technology keeps changing the work.

KF: Today it is very much about not losing the third dimension. I am doing "3-D pictures" because of colors that

are not real. I am somewhat between the two worlds.

TO: Your pieces seem virtual, but in real space.

KF: Maybe this is also the work's attraction.

TO: The experience of sculpture is similar to architecture in that you walk around it, you're in it, you're more aware of your heart and your body. You use your body to see the sculpture. And then, if you can, you touch it. It is literally a physical way to interact with it. My reading of Minimalism is that it's very figurative still, because we experience so much of it with our bodies. How big is it? Is it going to fall on me? Do I have to walk through it? Am I lost? There are emotions in this sense. There isn't an abstract experience of sculpture. You have to have a person there to see it.

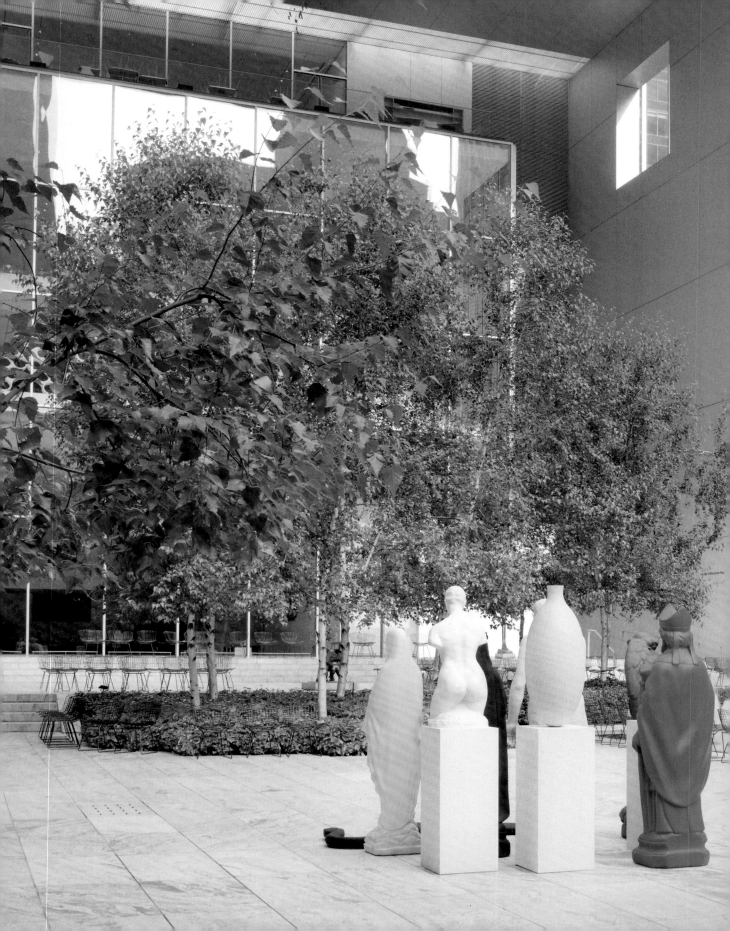

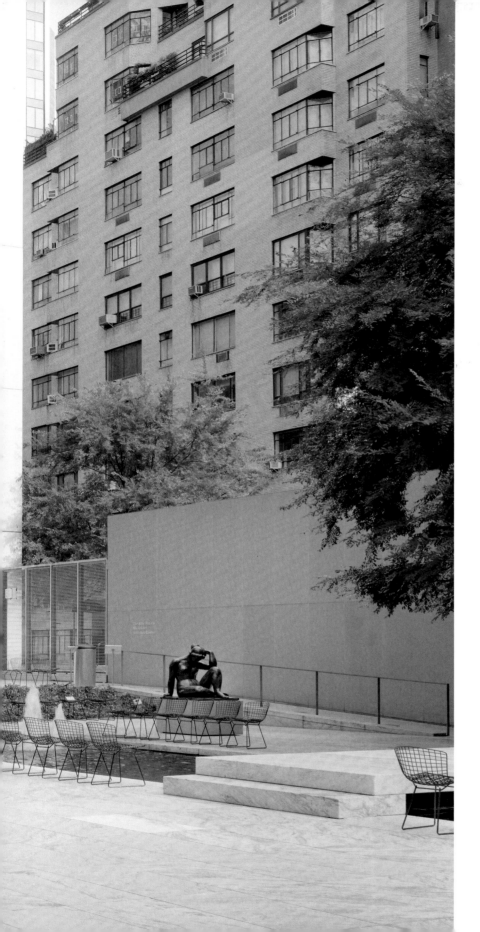

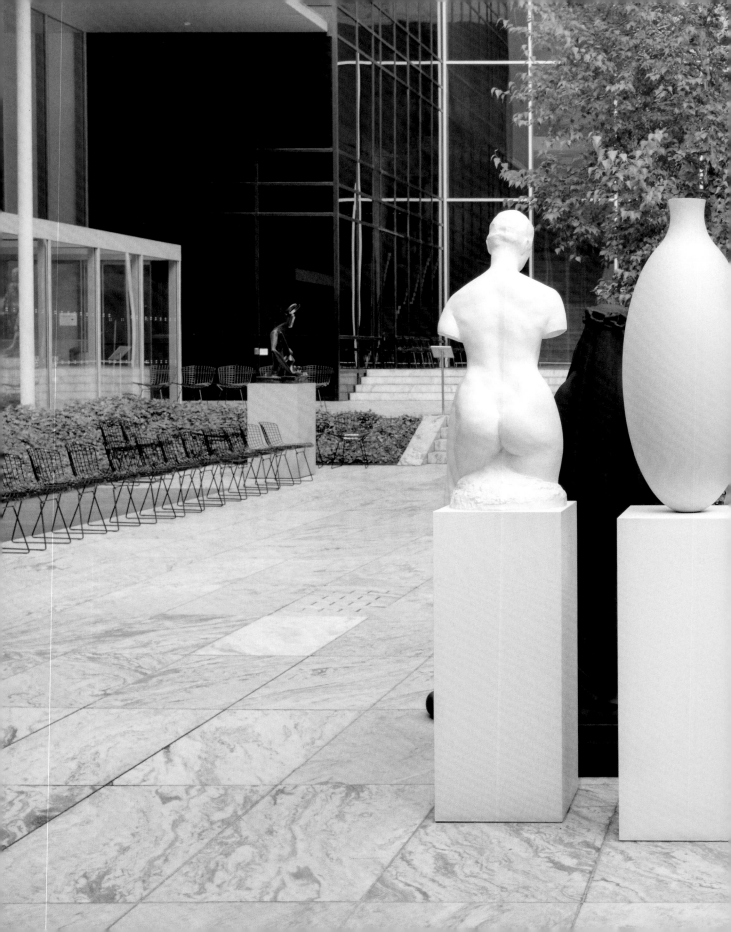

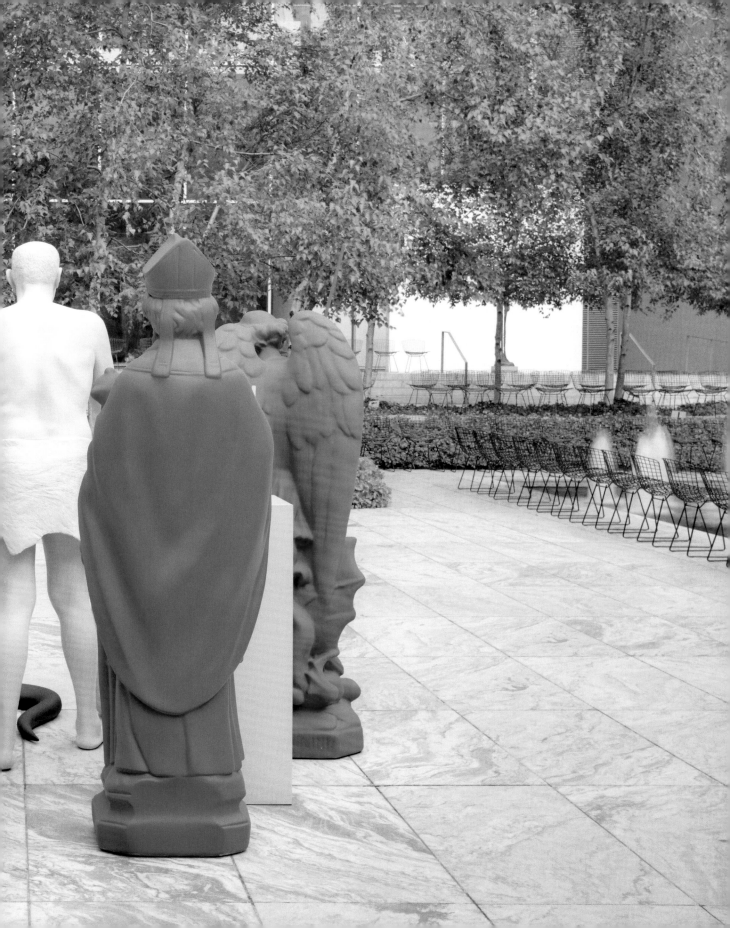

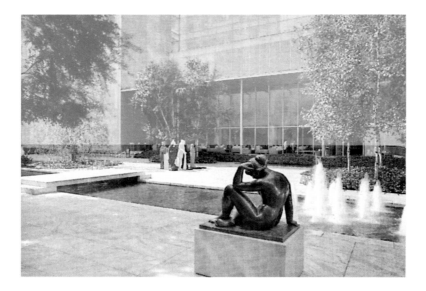

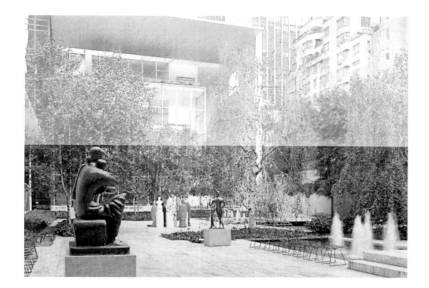

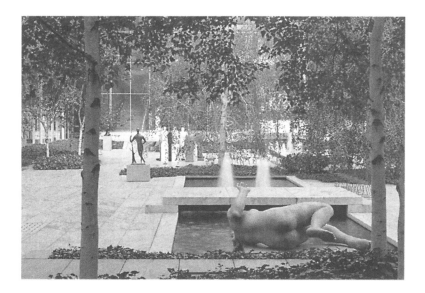

Works in the exhibition

Max Ernst
The King Playing with the Queen
1944 (cast 1954)
Bronze, 98 x 84 x 52 cm
Gift of D. and J. de Menil
© VG Bild-Kunst, Bonn
+ ADAGP, Paris 2013

Katharina Fritsch
Figurengruppe (Group of Figures)
2006–08 (fabricated 2010–11)
Bronze, copper, and stainless steel,
lacquered, 9 elements,
sizes range from 12 x 170 x 70 cm
to 200 x 40 x 40 cm
Gift of Maja Oeri and Hans Bodenmann
© VG Bild-Kunst, Bonn 2013

Alberto Giacometti
Grande Femme III (Tall Figure III)
1960
Bronze, cast for Gordon Bunshaft,
Susse Fondeur, 236 x 30 x 52 cm
Gift of Nina and Gordon Bunshaft
in honor of the artist, N°AGD 1254
© Alberto Giacometti Estate
(Fondation Alberto et Annette Giacometti,
Paris + ADAGP, Paris) 2013

Gaston Lachaise
Floating Figure
1927 (cast 1935)
Bronze, 131 x 244 x 56 cm
Given anonymously in memory of the artist
Courtesy Lachaise Foundation

Aristide Maillol
La Méditerranée (The Mediterranean)
1902-05 (cast c. 1951–53)
Bronze, 104 x 114 x 76 cm
Gift of Stephen C. Clark
© VG Bild-Kunst, Bonn 2013

La Rivière (The River)
1938–43 (cast 1948)
Lead, 137 x 229 x 168 cm
Lead base designed by the artist:
25 x 170 x 70 cm
Mrs. Simon Guggenheim Fund
© VG Bild-Kunst, Bonn 2013

Henri Matisse
Nu de dos I (The Back I)
1908–09
Bronze, 189 x 113 x 16.5 cm
Mrs. Simon Guggenheim Fund
© VG Bild-Kunst, Bonn 2013

Nu de dos II (The Back II)
1911–13
Bronze, 189 x 121 x 15 cm
Mrs. Simon Guggenheim Fund
© VG Bild-Kunst, Bonn 2013

Nu de dos III (The Back III)
1913–16
Bronze, 189 x 112 x 15 cm
Mrs. Simon Guggenheim Fund
© VG Bild-Kunst, Bonn 2013

Nu de dos IV (The Back IV)
c. 1931
Bronze, 188 x 112 x 15 cm
Mrs. Simon Guggenheim Fund
© VG Bild-Kunst, Bonn 2013

Joan Miró
Oiseau lunaire (Moonbird)
1966
Bronze, 229 x 198 x 145 cm
Nina and Gordon Bunshaft Bequest
© VG Bild-Kunst, Bonn 2013

Henry Moore
Family Group
1948–49 (cast 1950)
Bronze, 151 x 118 x 76 cm
A. Conger Goodyear Fund
© Henry Moore Foundation

Elie Nadelman
Man in the Open Air
c. 1915
Bronze, 138 x 30 x 55 cm
Gift of William S. Paley (by exchange)
© Elie Nadelman estate

Tom Otterness
Head
1988–89
Bronze, 37 x 97 x 119 cm
Acquired with matching funds from the
Louis and Bessie Adler Foundation, Inc.
and the National Endowment for the Arts,
and purchase

Pablo Picasso
La Chèvre (She-Goat)
1950 (cast 1952)
Bronze, 118 x 143 x 71 cm
Mrs. Simon Guggenheim Fund
© VG Bild-Kunst, Bonn 2013

Auguste Rodin
Saint Jean Baptiste prêchant
(Saint John the Baptist Preaching)
1878–80 (cast 1921)
Bronze, 200 x 94 x 57 cm
Mrs. Simon Guggenheim Fund

Renée Sintenis
Daphne
1930
Bronze, 149 cm high,
including sandstone base
Abby Aldrich Rockefeller Fund
© VG Bild-Kunst, Bonn 2013

Credits

Ivo Faber: Cover, p. 6/7, 8/9, 10/11, 13, 23, 25, 28/29, 40 (below), 44/45, 54/55, 56, 64/65, 72/73, 74/75, 82 (below), 84, 85, 87 (below), 93 © VG Bild-Kunst, Bonn 2013

Postkarten: p. 76, 77 Ivo Faber © VG Bild-Kunst, Bonn 2013, Katharina Fritsch © VG Bild-Kunst, Bonn 2013, Reproduced by permission of the Henry Moore Foundation; A. Maillol © VG Bild-Kunst, Bonn 2013; Elie Nadelman © Elie Nadelman estate

Katharina Fritsch: p. 14/15, 17, 19, 20, 26 (left, right, below), 30 (upper left, upper right, lower left, lower right), 37, 40 (above), 47, 49, 51, 52, 61, 62, 66, 69, 70, 76, 77 (2), 82 (above), 83, 86, 87 (above), 88 (above), 92, 94, 96, 97, 98, 99, 101 © VG Bild-Kunst, Bonn 2013

Photographic Archive: The Museum of Modern Art Archives, New York p. 18/80 © 2006 Timothy Hursley, 32 Photographer: Wurts Brothers, p. 33 Ezra Stoller © ESTO, p. 34 Photographer: Alexandre Georges, p. 38/39 Photographer: Alexandre Georges, p. 43, 88 (below) Photographer: Wurts Brothers, p. 89 Ezra Stoller © ESTO, p. 90 Photographer: Alexandre Georges, p. 91 Photographer: Alexandre Georges, p. 95

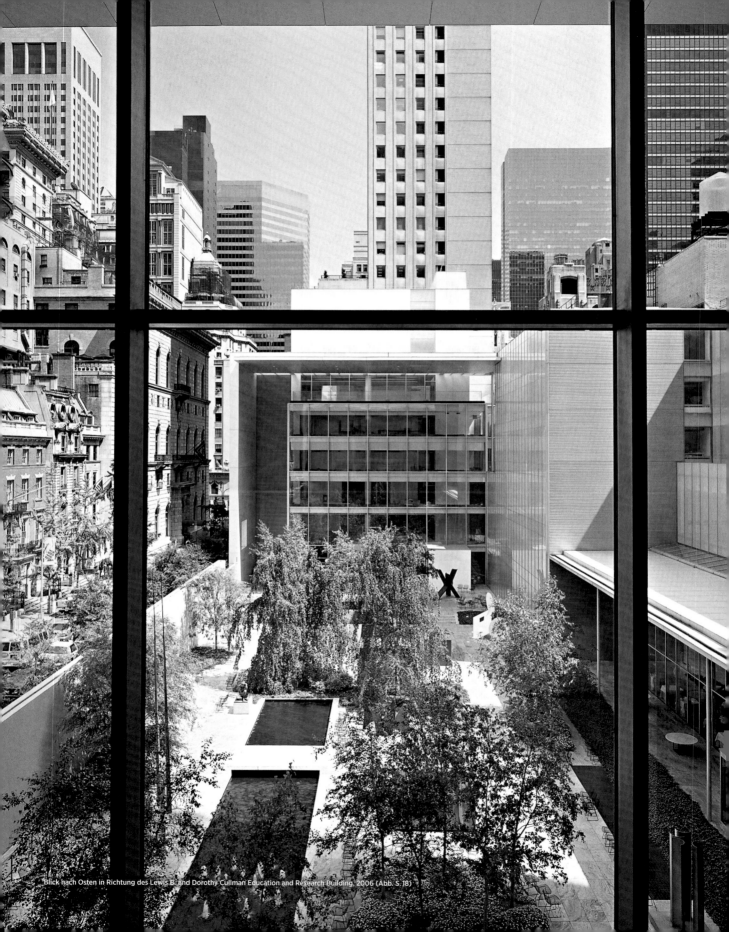

Blick nach Osten in Richtung des Lewis B. and Dorothy Cullman Education and Research Building, 2006 (Abb. S. 18)

Figure in
the Garden

Auf einer quadratischen Fläche steht eine Gruppe von Figuren. Sie lockt den Besucher durch ihre Farbigkeit heran, doch aus der Nähe wirken die einzelnen Gestalten in ihrer matten Monochromie unwirklich, wie Erscheinungen. Die Mitglieder dieser »Figurengruppe« stehen einfach beisammen, wie sich eine Besuchergruppe im Museum zusammenfindet. Die Gestalthaftigkeit lässt den Betrachter unmittelbar auf die lebensgroß dastehenden Figuren reagieren, doch mit ihren inneren Widersprüchen, ihren symbolischen Bezügen aus ganz unterschiedlichen religiösen und kulturellen Zusammenhängen präsentiert sich die Gruppe als unlösbares Rätsel, das Bezüge auf die eigene Lebenserfahrung, den eigenen kulturellen Hintergrund provoziert.

Die »Figurengruppe« stammt von Katharina Fritsch. Sie steht 2011 bis 2013 in der Ausstellung »Figure in the Garden« im Zentrum des Skulpturengartens des Museum of Modern Art. Das Museum hat diese umfangreiche Arbeit 2009 als Geschenk von Maja Oeri und Hans Bodenmann erhalten. Für Ann Temkin, Chefkustodin für Malerei und Skulptur, stellte die »Figurengruppe« einen beispielhaften Schritt der Skulptur ins neue Jahrhundert dar – und eines von wenigen Kunstwerken seit 2000, die für eine dauerhafte öffentliche Aufstellung im Skulpturengarten geeignet seien. Katharina Fritsch hat die Betonung der Polychromie und eine nicht mehr auf die Symmetrie angelegte, frei komponierte Skulptur seit der Jahrhundertwende erprobt.

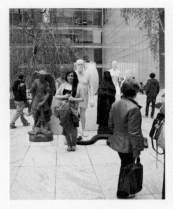

Katharina Fritsch, *Figurengruppe*, 2006–2008
(Abb. S. 17)

Im neuen Gebäude des Museum of Modern Art in New York gehen die meisten Besucher zunächst über die Räume für Gegenwartskunst im Erdgeschoss rasch in die Räume der Schausammlung im ersten Stock, die mit den »Vätern« des 20. Jahrhunderts (Cézanne, Gauguin, Seurat und Van Gogh) beginnen und dann zu Picassos »Demoiselles d'Avignon« (1907) führen. Durch die Glasfassade, die den Neubau von Yoshio Taniguchi (2004) zum Skulpturengarten hin öffnet, ergibt sich zugleich der Blick auf die Ausstellung »Figure in the Garden«. Der Skulpturengarten wurde 1953 als »roofless gallery«, als Ausstellungsraum ohne Dach, eingerichtet.

In der langen Ankaufstradition des Museums stellt die »Figurengruppe« (2006–2008) von Katharina Fritsch die erste mehrfarbige, aus mehreren Figuren bestehende Großskulptur dar. »Figure in the Garden« ist deshalb so interessant, weil die Ausstellung rund um die »Figurengruppe« organisiert ist. Gezeigt werden Werke von Auguste Rodin, Aristide Maillol, Pablo Picasso, Henri Matisse, Max Ernst, Alberto Giacometti, Renée Sintenis, Elie Nadelman, Gaston Lachaise, Joan Miró, Henry Moore sowie Tom Otterness in dialogisch-räumlichen Bezügen zueinander. Mit 16 Bronzeplastiken aus den letzten 130 Jahren stellt »Figure in the Garden« nicht nur eine Übersicht über die figurative Skulptur seit 1880 dar. Ann Temkin zäumt das Pferd bewusst von hinten auf, indem sie die Geschichte der Figur in der Skulpturensammlung von der Gegenwart rückwärtsliest, bis zu den Anfängen der modernen Skulptur. Die Ausstellung geht von Fritschs »Figurengruppe« als der einzigen im Freien aufstellbaren Skulptur der Sammlung des Museums aus, die im 21. Jahrhundert entstanden ist, und gruppiert die übrigen Skulpturen im Verhältnis zu dieser zeitgenössischen Arbeit. Damit stellt die Ausstellung viele interessante Fragen zur Geschichte der Skulptur und zu den Verschiebungen in der Skulptur der Gegenwart.

Rund um die farbigen Figuren von Katharina Fritsch, deren Anordnung mit der Frontalität arbeitet, stehen unbemalte Bronzeskulpturen. Die figurative Bronzeskulptur der Moderne wird aus der Gegenwart befragt, ausgehend von einer exemplarischen Arbeit des frühen 21. Jahrhunderts. Die 16 Plastiken im Skulpturengarten erscheinen wie ein Ballett posierender, schreitender, kauernder, aus der Fläche erscheinender und sich im Raum behauptender Körper, in deren Mitte Fritschs mysteriöse farbige Gestalten und Gegenstände unbeweglich stehen. Die Ausstellung spinnt die

Katharina Fritsch, *Figurengruppe*, 2006–2008
(Abb. S. 23)

Fäden von der Gegenwart aus, von der erscheinungs-
haften Körperlichkeit der Arbeit von Katharina Fritsch
zum »Saint Jean Baptiste prêchant«, Rodins frühem
Meisterwerk (1878–1880). Bemerkenswert ist der Um-
stand, dass die Werke lebender Künstler sich gleichsam
selbstverständlich in eine gleichberechtigte Beziehung
zu zentralen Werken jener Bildhauer gesetzt sehen, die
die wesentlichen Werke figuraler Skulptur im 20. Jahr-
hundert geschaffen haben.

An der Arbeit von Katharina Fritsch – wie auch an
»Head« (1988/1989) von Tom Otterness, der zweiten
zeitgenössischen Arbeit der Ausstellung – lassen sich
einige innovative Brüche mit der Tradition der moder-

Tom Otterness, *Head,* 1988/1989 (Abb. S. 19)

nen Skulptur ablesen. In »Head« sind bereits wesentliche Neuerungen bezüglich
des Begriffs des Körpers, des Objekts und des Verhältnisses zur Tradition der
Bronzeskulptur angedeutet, die sich in der »Figurengruppe« zugespitzt finden.
Die »Figurengruppe« besteht aus neun Objekten bzw. Skulpturen, deren for-
male Strenge das Vorbild der Minimal Art verrät, während durch die Frontali-
tät, neben der Vielgestaltigkeit, der Polychromie, der Vertikalität der Gestalten,
ihrem figurativen Charakter und dem Spiel mit dem Sockel, eine Reihe von
Regeln der modernen Skulptur bewusst gebrochen werden. In »Figure in the
Garden« lässt dieser Gegensatz zu den skulpturalen Mitteln der modernen
Skulptur die zeitgenössische Auffassung der menschlichen Gestalt, den gewan-
delten Begriff des Körpers deutlich vor Augen treten. Katharina Fritschs Figu-
ren sind mechanisch vergrößerte Objekte der Alltagswelt und dreidimensional
abgenommene konkrete Gestalten, anschließend händisch modelliert und
monochrom mit matten Farben bemalt, während Rodin im Sinne der Impressi-
onisten, seiner Generationsgenossen, den heroischen Versuch unternahm, vom
lebendigen Modell in voller Bewegung auszugehen und die Skulptur von innen
nach außen zu modellieren.

Die »Figurengruppe« bildete eine Außenskulptur bei Katharina Fritschs Aus-
stellung im Kunsthaus Zürich 2009 und die Eingangssituation zu jener in den
Deichtorhallen Hamburg im selben Jahr. Neun Gestalten stehen in einer dreirei-
higen Formation. In der ersten Reihe befinden sich eine betende gelbe Madonna,
eine schwarze Heilige, ein hochgewachsener, auf eine Keule gestützter, grauer
Urmensch und ein chromoxidgrün gefärbter heiliger Michael. Diese vier Figuren
sind in vergleichbare körperliche Größe gebracht. Vor ihnen liegt eine schwarze,
etwas geometrisierte Schlange. Sie ist formal stärker durchgestaltet als die Kör-
per in der ersten Reihe, wodurch sie verfremdet, als Kunstobjekt aber zugleich

vertraut wirkt. Hinter diesen gelben, schwarzen, grauen und dunkelgrünen Gestalten stehen vier weitere Figuren, neutral grau bemalt mit Ausnahme des violetten Heiligen hinter dem Riesen. Diese zweite Reihe ist durch rätselhafte Bezüge bestimmt. Ein weiblicher Torso, ein Skelettfragment und eine geometrische Vase, jeweils auf einfachen Sockeln, machen die »Figurengruppe« als offen angelegte Allegorie mit aktuellen Bezügen und weitgespannten Bedeutungsfeldern erkennbar. Die Polychromie entfaltet sich in der ersten Figurenreihe, während die Grautönung der übrigen Objekte im Dialog mit dem Violett des heiligen Nikolaus in der »Figurengruppe« die räumliche und allegorische Tiefe gibt.

Die mehrteilige Skulptur folgt einer Kunst des zufälligen Nebeneinanders, wie Susan Sontag in den sechziger Jahren ein gemeinsames Formprinzip von Pop Art, Happening, Minimal und Conceptual Art kennzeichnete.[1] Sie ist aus bestehenden, seit 2003 unabhängig voneinander produzierten Arbeiten im Düsseldorfer Atelier der Künstlerin entstanden, bevor die Farbgebung festgelegt

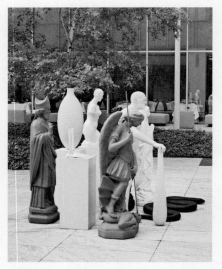

Katharina Fritsch, *Figurengruppe*, 2006–2008 (Abb. S. 10/11)

wurde, die der Arbeit erst ihre Wirkung verleiht. Man kann sie auch als eine »allégorie réelle« lesen, die von transformierten Elementen der Wirklichkeit gebildet wird wie in Gustave Courbets berühmtem Gemälde »L'Atelier du peintre, allégorie réelle déterminant une phase de sept années de ma vie artistique« (1855).[2] Die Ausführung der 2006 bis 2008 in leichtem Polyester realisierten Figurengruppe als witterungsbeständige, monochrom bemalte Metallskulptur (Galvanoplastik und Bronze) für den Skulpturengarten hat der Arbeit eine zusätzliche Eindringlichkeit verliehen. Wie Courbet verwendet Katharina Fritsch keine geläufigen – medialen – Bilder der Gegenwart. Die »Figurengruppe« sucht die direkte Wirkung von Gestalten, die im kollektiven Bewusstsein eine Rolle spielen und deren Emotionalität von der Farbe verstärkt und in Mehrdeutigkeit überführt wird, während die matte Bemalung die Figuren in nicht genau bestimmbare Erscheinungen verwandelt. Diese Arbeit erträgt den Dialog mit der Geschichte der Skulptur in den subtilen Beziehungsnetzen der Ausstellung »Figure in the Garden«.

Wenn man die »Figurengruppe« als »reelle Allegorie« betrachtet, fällt auf, dass sie ebenso wie Courbets Gemälde aus »tableaux« besteht, scheinbar leicht zuzuordnenden Images, die ein persönliches Universum an Bildern vorstellen, jedoch nicht direkt mit den Sphären unserer zeitgenössischen Bildöffentlich-

keit vermittelt sind. In ihren inhaltlichen Bezügen, von der Madonna bis zu den Fragmenten auf den Sockeln, erschließt sich die »Figurengruppe« keineswegs unmittelbar. Alle neun Figuren haben einen hohen Realitätswert. Der graue Riese etwa ist ein in die skulpturale Dimension übernommener Taxifahrer. Doch ist diese Figur nicht zurückgebunden an die Erzählungen unserer Gegenwart, an mediale Themen und Bildwelten unserer Epoche. Da sie realistisch, zeitgenössisch und zugleich bezuglos innerhalb der zeitgenössischen Diskurse sind, nehmen die Gestalten einen offen-allegorischen Charakter an. Konkrete Bedeutungen, Verweise und Kontexte gibt es im aufgelösten Verweiszusammenhang unserer nachmodernen Epoche offenbar nicht mehr. Gerade in ihrem Verzicht auf Verweise werden die neun realistischen Gestalten, die über die Ikonografie unserer Gegenwart hinausgreifen, zeitgenössische Allegorien.

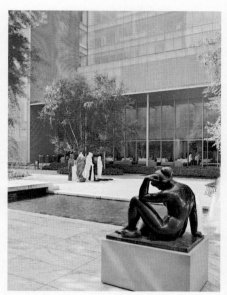

(Abb. S. 25)

Die Mehrfarbigkeit, anziehend und virtualisierend, unterscheidet die »Figurengruppe« von den übrigen Bronzearbeiten im Skulpturengarten. Natürlich ist sie keineswegs die einzige mehrfarbige Skulptur in der modernen, zumal zeitgenössischen Skulptur: Die Arbeiten von Reiner Ruthenbeck, Sigmar Polke und Gerhard Richter sind neben den mehrfarbigen Skulpturen von Donald Judd als frühe Einflüsse der Künstlerin auszumachen, vor allem aber der singuläre Weg ihres Lehrers an der Kunstakademie Düsseldorf, Fritz Schwegler, der ab 1972 Farbigkeit und einen performativen Skulpturbegriff zusammenführte.

Von diesen modernen Vorbildern hebt sich Katharina Fritsch durch die reinen Farbtöne und eine matte Bemalung ab, die alle Lichtreflexe ausschließt. Geht es bei Rodins polierter Bronzeskulptur darum, durch das Spiel des Lichts auf der Oberfläche die Dreidimensionalität und die Funktion der Muskeln zu betonen und durch wechselnde optische Wirkungen lebendig werden zu lassen, so ist bei der »Figurengruppe« die gelbe, schwarze, grüne, violette und graue Bemalung der Gestalten derart gleichmäßig monochrom aufgetragen, dass das Umgebungslicht die Figuren kaum zu berühren scheint. In der »Figurengruppe« ist jede Farbe befremdlich gegenüber der Gestalt. Die Auswahl der Farben ist subjektiv, doch sie werden keineswegs expressiv eingesetzt. Die Farben präzisieren die Objekte, geben ihnen aber auch etwas Unwirkliches, Erscheinungshaftes. Damit geht ein übergreifender Farbklang einher, obgleich jede Figur durch eine besondere Farbe identifiziert bleibt.

Gleich am Eingang der Ausstellung ergibt sich ein interessanter Dialog zwischen dem Riesen in Fritschs Ensemble und Rodins »Saint Jean Baptiste prêchant«. Drückt Rodin mit dem beständigen Wechsel des Lichts eine Wahrnehmung der Natur aus, die an Monet erinnert, so geht es bei Fritsch um die Unwirklichkeit einer gleichwohl überaus präsenten, in bildhauerischer Hinsicht makellosen Figur. Scheint die Figur bei Rodin von innen nach außen entwickelt, so fehlt dieser Eindruck bei Fritsch, deren Figuren lediglich einen Objektcharakter als bloße Form oder Hülle besitzen. Ihr anorganischer Körperbegriff setzt sich von Rodins organischer Körperbehandlung ab, sie zeigt den Körper als standardisiertes, unwirkliches Objekt.

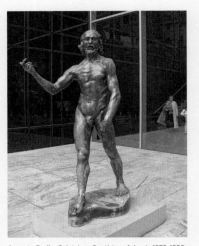

Auguste Rodin, *Saint Jean Baptiste prêchant*, 1878–1880 (Abb. S. 20)

Rodin ließ seine Modelle im Atelier auf und ab schreiten, während er modellierte. Er rückte die Darstellung der Bewegung als Ausdruck des »élan vital« ins Zentrum seiner skulpturalen Arbeit. So zeigt er Johannes den Täufer bei seiner Rede mit einer spontanen Geste des Arms, wodurch die Körperhaltung destabilisiert wirkt und der Körperschwerpunkt außerhalb der Standfläche anzukommen scheint wie in vielen späteren Skulpturen des Künstlers. Bewegung und räumliche Dynamik, grundlegende Themen der modernen Skulptur, werden bei Fritsch verweigert, um den Objektcharakter der Körper zu betonen.

Aristide Maillol, *La Méditerranée*, 1902–1905 (Abb. S. 26)

Ausgehend von dieser Thematik zeigt die Ausstellung »Figure in the Garden«, wie differenziert und sensibel wichtige Bildhauer des 20. Jahrhunderts mit der Bewegung und der räumlichen Dynamik der Skulptur umgegangen sind. Ebenso fällt auf, dass die zeitgenössischen Künstler dieser Ausstellung, Tom Otterness und Katharina Fritsch, andere Akzente setzen.

Zu Beginn des 20. Jahrhunderts hat Aristide Maillol die Skulptur »La Méditerranée« (1902–1905, posthumer Guss von ca. 1951–1953) zwar nicht mehr impressionistisch wie Rodin, aber ebenso feinfühlig von innen heraus modelliert. Sich entschieden gegen Rodin wendend, interpretierte er die Bewegung durch den möglichst reinen Ausdruck der Ruhe. Dieses Statische, Architektonische bei Maillol, aber auch seine Betonung der geschlossenen

Form erklären den enormen Einfluss dieses Werks auf die Bildhauerei in der ersten Hälfte des 20. Jahrhunderts, unter anderem auf den Düsseldorfer Kunststudenten Wilhelm Lehmbruck, dem das Museum of Modern Art bereits 1930, ein Jahr nach seiner Gründung, eine Einzelausstellung gewidmet hat – zeitgleich mit der ersten Retrospektive von Aristide Maillol.

Im selben Jahr hat Renée Sintenis in »Daphne« das Thema der Bewegung in einer freien, tänzerischen Form als Eroberung des Raums und Befreiung des Körpers aufgefasst, womit sie die revolutionären künstlerischen Bewegungen der Epoche synthetisierte: Kubismus, Futurismus, Konstruktivismus und Dada. Sintenis war eine bekannte deutsche Bildhauerin, die von der Galerie Flechtheim vertreten wurde, nach 1945 Professorin in Ost- und Westberlin war (beispielsweise auch während der Studienjahre von Georg Baselitz) und schließlich den »Berliner Bären« entwarf. Ihre »Daphne« wurde 1939 erworben – einer der frühen Ankäufe der Skulpturensammlung. Es zählt zum Potenzial kontinuierlich und präzise zusammengeführter Sammlungen, für die das Museum

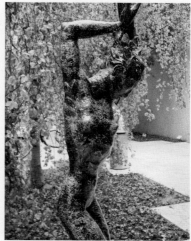

Renée Sintenis, *Daphne*, 1930 (Abb. S. 26)

of Modern Art im 20. Jahrhundert beispielhaft steht, dass sie Künstlerinnen und Künstler gegenwärtig halten, die in ihrem Heimatland so gut wie vergessen sind und deren Werke auf dem internationalen Kunstmarkt seit Langem nicht mehr präsent sind. Ohne die wiederholte Ausstellung der »Daphne« von Renée Sintenis im Skulpturengarten wäre das Werk dieser Künstlerin in Deutschland vergessen, obgleich die Berliner Museen mehrere Skulpturen in ihren Sammlungen haben.[3] Die letzte Monografie über Sintenis ist 1947 in der DDR erschienen.[4] Das Museum of Modern Art dürfte das einzige Museum sein, in dem zurzeit ein Werk dieser Bildhauerin zu sehen ist, dabei ist ihre Arbeit für die Skulptur des

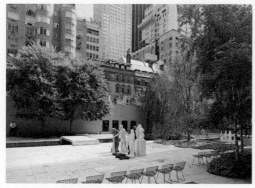

Katharina Fritsch, *Figurengruppe*, 2006–2008 (Abb. S. 28/29)

20. Jahrhunderts durchaus bemerkenswert – zumal, wenn man die bis in die fünfziger Jahre virulenten Schwierigkeiten für Künstlerinnen bedenkt, sich im Bereich der Bildhauerei die Möglichkeit einer eigenen dauerhaften Arbeit zu erobern.

Zwischen dem frühen Werk von Maillol und der Skulptur von Renée Sintenis situieren sich Henri Matisses Bronzereliefs »Nu de dos« I, II, III und IV (1908–1931), die unabhängig voneinander entstanden sind und in ganz unterschiedlicher

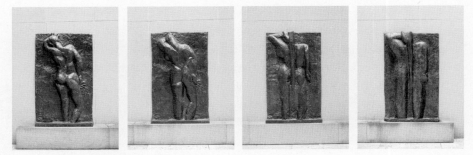

Henri Matisse, *Nu de dos (I, II, III, IV)*, 1908–1931 (Abb. S. 30)

Weise den Fragen der Bewegung und der Dauer, der Flächigkeit und der Räumlichkeit, des Körpers und der Geometrie, der Kontur und der abstrakten Fläche nachgehen. Drei dieser Flachreliefs wurden 1952 (noch zu Lebzeiten des Künstlers), das vierte 1956 (kurz nach seinem Tod) erworben, nachdem Alfred H. Barr Jr. 1951 Matisse eine bahnbrechende Monografie gewidmet hatte,[5] nach seinem Picasso-Buch von 1946[6] die zweite umfassende Monografie für einen Künstler der klassischen Moderne. Das Umgebungslicht wird von Matisse auf der »malerisch« behandelten Oberfläche dieser Flachreliefs aufgelöst, deren erstes zeitgleich mit seinen großen malerischen Kompositionen »La Danse« entstanden ist. Zugleich entwickeln sich diese drei skulpturalen Reliefs zunehmend in die Zweidimensionalität und zu einer abstrakten Zeichensprache, während die klare, organisch in der Beobachtung der Modelle erarbeitete Form immer erhalten bleibt. In ihrer simultanen Präsentation, die vom Künstler nicht intendiert war, aber mit den inneren Gesetzen seiner Arbeiten übereinstimmt, erreichen sie eine kinematografische Qualität, die wiederum dem szenischen Charakter der »Figurengruppe« korrespondiert.

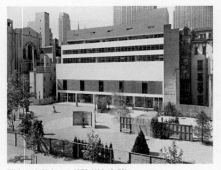

Blick nach Südosten, 1939 (Abb. S. 32)

Derartige Konfrontationen zwischen Skulpturen aus der Sammlung – und zwar in unmittelbarer Nähe zur Schausammlung des Museums – entsprechen dem Gedanken, der zur Schaffung des Skulpturengartens in den Jahren 1939 bis 1953 führte. Das 1929 in New York gegründete Museum of Modern Art war eine Institution für Ausstellungen der wichtigen Kunst des 20. Jahrhunderts, besaß aber zunächst keine eigene Sammlung. Schon vor 1939 hat das Museum als erste Institution überhaupt eine Konzeption umgesetzt, in der Skulptur, Malerei, Architektur, Design, Fotografie und Film gleichwertig nebeneinanderstanden. Dieses Konzept war erklärtermaßen inspiriert vom Bauhaus und den fortschrittlichen deutschen Museen

Figure in the Garden

wie dem Museum Folkwang, das sich damals noch in Hagen befand, und dem Landesmuseum Hannover, also der Ausstellungspraxis von Alexander Dorner. Während in New York in den zunächst nur angemieteten Räumen an der Ecke Fifth Avenue/57. Straße und seit 1932 in einem Haus am gegenwärtigen Standort 11 West 53rd Street bahnbrechende Ausstellungen wie »Cubism and Abstract Art« und »Dada, Fantastic Art and Surrealism« (beide 1936) stattfanden, wurden die Künstler der Moderne in Europa mit dem Triumph von Faschismus und Nationalsozialismus zum Schweigen gebracht oder in die Emigration getrieben. Der Board of Trustees traf dann die Entscheidung, dem Museum besonders durch den Aufbau einer unvergleichlichen Sammlung von Malerei, Skulptur, Fotografie, Film, Architektur und Design Dauer zu verleihen.

Die erste Form des Skulpturengartens war im Mai 1939 im Rahmen der Ausstellung »Art in Our Time: 10th Anniversary Exhibition« zu sehen, der bis dahin umfassendsten Übersicht über die Kunst der klassischen Moderne. Mit dieser Ausstellung wurde zugleich das neue Gebäude an der 53. Straße eröffnet, das Philip L. Goodwin und Edward Durell Stone entworfen hatten. In diesem Zusammenhang erwarb John D. Rockefeller, der 1936 den Bauplatz für den Museumsbau gespendet hatte und dessen Frau Abby Aldrich Rockefeller zu den Gründungstrustees zählte, 1937 für das Museum auch jenes Grundstück an der 54. Straße, auf dem sich der Skulpturengarten bis heute befindet. Die Rockefellers hatten für die neue Museumssammlung zu diesem Zeitpunkt zahlreiche moderne Skulpturen gestiftet, darunter Arbeiten von Gaston Lachaise, Aristide Maillol, Wilhelm Lehmbruck, Henri Matisse, Amedeo Modigliani und William Zorach. So erklärt sich die Benennung als »Abby Aldrich Rockefeller Sculpture Garden«, die bei der Wiedereröffnung im April 1953 eingeführt wurde. Abby Aldrich Rockefeller war 1948 verstorben.[7]

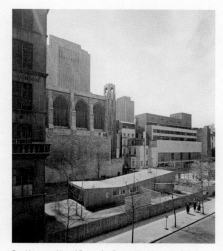

Das Haus von Marcel Breuer im Garten des Museum of Modern Art, 1949 (Abb. S. 33)

Im Mai 1939 gestalteten Alfred H. Barr Jr., Gründungsdirektor und Kurator der Ausstellung, und John McAndrew, Kustos für Architektur, in den beiden Wochen vor der Eröffnung den Skulpturengarten. Sie strukturierten den Raum durch geschwungene Stellwände und Vorhänge, deren Form von Hans Arp inspiriert war. Neben den Sichtblenden zwischen den Skulpturen wurden auch diese selbst zur Gliederung des Raumes eingesetzt. Es handelte sich um den ersten Skulpturengarten in einem Museum, wozu Rodin und Maillol, die Skulpturen außerhalb ihrer Ateliers aufgestellt hatten, mögli-

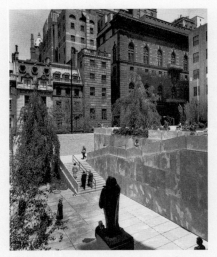

1964 wurde der Skulpturengarten durch eine zweite Terrasse und eine große Treppe nach Entwürfen von Philip Johnson erweitert. (Abb. S. 34)

cherweise eine Anregung lieferten. Der Skulpturengarten entstand also als Raum einer Ausstellung (mehr als 20 von den 60 Skulpturen bei »Art in Our Time« waren hier aufgestellt), nicht als vergleichsweise statischer Außenbereich der Dauerausstellung, wie es später bei den meisten Skulpturengärten in europäischen Museen der Fall war, die in den späten fünfziger und frühen sechziger Jahren eingerichtet wurden. Bis heute begreift das Museum of Modern Art den Skulpturengarten als eine »outside gallery«, in der wechselnde Ausstellungen zu sehen sind, nicht enzyklopädische oder chronologische Sammlungspräsentationen.

Neun Jahre nach der Eröffnung erläuterte Barr: »Our original plan for the garden was of course just as anti-mechanistic as possible. We laid it out in free curves inspired by Arp, partly by English garden tradition with screens as background for the sculpture and as much informal planting as we could afford. [...] The garden was designed to contrast with the severe rectangular layout of the rear façade of the Museum, not to mention the severe rectangular layout of the surrounding New York City.«[8]

1942 wurde im nicht überdachten Bereich an der 54. Straße ein großes Restaurant eröffnet. Mit der Konsolidierung des Hauses unter dem neuen Direktor René d'Harnoncourt ab 1949 und der Rehabilitierung der Gedanken und der Rolle von Alfred H. Barr Jr. zu Beginn der fünfziger Jahre bekam die Einrichtung eines speziell für diesen Zweck konzipierten Skulpturengartens Priorität. Den Auftrag erhielt Philip Johnson.

Johnson hatte wie Barr, zum Teil auch gemeinsam mit ihm, in den zwanziger und dreißiger Jahren ausgedehnte Reisen durch Europa unternommen, wobei er zahlreiche Protagonisten der klassischen Moderne kennenlernte. Von 1932 bis 1934 war er Direktor des Department of Architecture, bevor er 1936 auf Anraten von Ludwig Mies van der Rohe selbst Architekt wurde. Von 1940 bis 1943 studierte er in Harvard. Dort waren seit 1937 auch die deutschen Emigranten Walter Gropius und Marcel Breuer tätig, die Johnson zusammen mit Mies van der Rohe bereits am Bauhaus getroffen hatte. 1947 kuratierte er im Museum of Modern Art die erste Retrospektive von Mies van der Rohe, die sich als wahrer Triumph herausstellte.[9] Zwei Jahre später wurde er erneut Direktor der Architekturabteilung und konzipierte in dieser Funktion den Skulpturengarten.

Der im April 1953 eröffnete »Abby Aldrich Rockefeller Sculpture Garden« von Philip Johnson wurde wegen seines Dialogs von klaren Flächen und figurati-

ven Skulpturen wiederholt mit Mies van der Rohes »Barcelona-Pavillon« auf der Weltausstellung von 1929 verglichen. Während allerdings in Mies' Meisterwerk der Architektur des 20. Jahrhunderts die Skulptur den architektonischen Raum unterstützt, verhält es sich bei Johnsons Skulpturengarten gerade umgekehrt, was wiederum den Skulpturengarten zu einem Exempel gelungener Ausstellungsarchitektur im 20. Jahrhundert macht.

Johnson gestaltete den »outdoor room« mit einer fensterlosen, grauen Ziegelmauer gegenüber dem Autoverkehr in der 54. Straße, an der bereits 1953 die drei Flachreliefs von Henri Matisse zu sehen waren, an derselben Stelle wie jetzt bei »Figure in the Garden«. Nach innen, zum Museumsgebäude bzw. aus diesem heraus zum Garten, gibt es dagegen durchgehende Glaswände und -türen, um die größtmögliche Transparenz und Fluidität zwischen den Innenräumen und dem Skulpturengarten zu gewährleisten. Bis heute zählt der Dialog von innen und außen, Malerei bzw. zweidimensionalen Kunstwerken und Installationen auf der einen, Skulpturen auf der anderen Seite zu den besonderen Möglichkeiten des Museum of Modern Art.

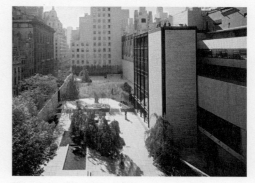

Blick nach Osten, 1964 (Abb. S. 38/39)

In sich ist der Skulpturengarten als elegante urbane Parklandschaft angelegt, die zwar beruhigend gegenüber dem intensiven städtischen Getriebe Manhattans wirken soll, zugleich aber die orthogonale Gliederung der Stadt poetisch aufgreift.[10] Als abgesunkener Garten etwas niedriger als die Grundfläche des umgebenden Museumsbaus, gewährt der Skulpturengarten dem Betrachter bereits beim Betreten eine Übersicht über den vielfältigen Dialog, in dem sich die Skulpturen befinden. Wasser- und Rasenflächen, Bäume und Sträucher (»pseudo-accidental planting areas«[11]) sind so gesetzt, dass sie die Skulpturen nicht verdecken. Diese bleiben von fast jedem Standpunkt aus gleichzeitig sichtbar. Damit unterscheidet sich der Garten von 1953, der in mannigfaltiger Hinsicht auf japanische Gartentraditionen verweist, deutlich von der ersten Gestaltung von 1939 mit ihren die Skulpturen überragenden Trennwänden. Stattdessen sorgen die zentrale Piazza aus Marmor aus Vermont, die beiden rechteckigen Wasserbecken, die vier weiteren offenen Räume für die Aufstellung von Skulpturen und die beiden kaum merklich erhöhten Terrassen an den seitlichen Fassaden für eine Strukturierung, die die Skulpturen klar im Raum verortet, ohne sie visuell zu trennen. So beschrieb Johnson auch 1950 sein Projekt: »All these measures (the wall on the street, water-channels, bridges) will provide four different areas and backgrounds in which to display various kinds of sculptures. There will be an open central plaza

for monumental works, a long narrow plaza, a small square and a large square.« Und 1953 schrieb er im »New Yorker«: »[...] a roofless room with four subrooms formed by the planting and the canals, to provide four space backgrounds for the sculpture«.[12] Auf eine horizontale Fläche angewandt, realisiert der Skulpturengarten von Philip Johnson in bis heute erhaltener Frische eines der schönsten Beispiele modernistischer Architektur.

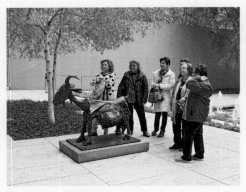

Pablo Picasso, *La Chèvre*, 1950 (Abb. S. 37)

Zur Eröffnung des neuen Skulpturengartens konzipierte Andrew C. Ritchie, Chefkustos für Malerei und Skulptur, im April 1953 die Ausstellung »Sculpture of the Twentieth Century«, die erste umfassende Bilanz der Hochkonjunktur, die die Skulptur in den Jahren nach dem Zweiten Weltkrieg in Europa wie in den USA erlebte.[13] Zwölf Skulpturen standen, von Johnson und d'Harnoncourt platziert, im Garten, der Rest in den angrenzenden Ausstellungsräumen. Der zentrale Platz, der bei »Figure in the Garden« der »Figurengruppe« von Katharina Fritsch zukommt, wurde von Pablo Picassos »Homme à l'agneau« (1943/1944) eingenommen, der später nicht in die Sammlung kam, anders als seine »Chèvre« von 1950, die seit dem Erwerb im Jahr 1959 der Publikumshit im Skulpturengarten ist. Sie tritt nun in »Figure in the Garden« in einen interessanten Dialog mit der »Grande Femme III« von Alberto Giacometti (1960, erworben 1969), bei der sich eine ähnliche Modelliertechnik findet. Was in Picassos Malerskulptur mit spielerischer Inkonsequenz umgesetzt wird, dient bei Giacometti einer konsequenten Auflösung der Oberfläche, die bis an die Grenze der Zerstörung der menschlichen Gestalt in eine schier unendliche vertikale Linearität fortschreitet. Bei der Eröffnungsausstellung von 1953 haben Johnson und d'Harnoncourt interessanterweise ausschließlich figurative Skulpturen für den Garten gewählt, obwohl die Ausstellung »Sculpture of the Twentieth Century« viele abstrakte Arbeiten zeigte. Dieser Umstand verweist bereits auf einen latenten Konflikt zwischen der Architektur des Gartens und der ungegenständlichen Skulptur, zumal der Skulptur des Abstrakten Expressionismus und der nachfolgenden Minimal Art. Selbst die ersten, gleichfalls 1953 entstandenen Außenarbeiten von Alexander Calder, der bereits ein Jahr nach der Eröffnung des Museums in einer Ausstellung, 1939 dann auch bei »Art in Our Time« prominent vertreten war, 1952 auf der Biennale von Venedig den Großen Preis erhielt und 1969 eine große Retrospektive im Museum of Modern Art bekam, schienen nicht nur den Maßstab von Johnsons Architektur zu sprengen. Auch ein Dialog abstrakter Flächen

Figure in the Garden

mit der selbst flächig angelegten Architektur des Skulpturengartens stellte sich nicht ein. Das war noch deutlicher bei der Aufstellung eines Werks von Tony Smith der Fall, dem 1998 eine große Retrospektive gewidmet war, wie bei den Künstlern der Minimal Art. In späteren Ausstellungen im Skulpturengarten wurden Calder, Smith und die Minimalisten oft berücksichtigt und auch wiederholt zusammen mit figurativer Skulptur gezeigt, wobei stets eine Disharmonie spürbar blieb. Vor diesem Hintergrund ist es interessant zu beobachten, dass die Skulpturen von Katharina Fritsch und Tom Otterness mit diesem Environment des frühen Modernismus wesentlich besser harmonieren.

Gleichfalls in der Eröffnungsausstellung des Skulpturengartens 1953 zu sehen und in einer ähnlichen Stellung zu einem der beiden Wasserbecken angebracht wie in »Figure in The Garden« war der vollfigürliche, scheinbar ins Wasser abtauchende Akt »La Rivière« (1938–1943) von Aristide Maillol. Der Bildhauer war 1944 im Alter von 63 Jahren verstorben. Er hatte ab 1938 diese Arbeit mit ihrer prallen weiblichen Form – möglicherweise eine seiner letzten Zusammenfassungen der klassischen Form – als Gegenstück zur gleichfalls in Blei gegossenen Skulptur »La Montagne« (1925) ausgeführt, die sich unter den Maillol-Arbeiten befindet, die André Malraux als erster französischer Kulturminister zur Erneuerung der französischen Museumslandschaft ab 1960 im Jardin des Tuileries aufstellen ließ – inspiriert vom New Yorker Skulpturengarten. »La Rivière« wurde 1948 posthum in Blei gegossen und im folgenden Jahr vom Museum of Modern Art erworben.

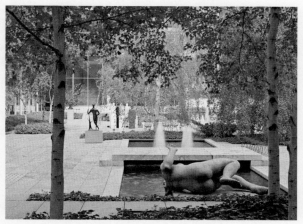

Aristide Maillol, *La Rivière*, 1938–1943 (Abb. S. 40)

Heute können wir an dieser Gestalt den Drang nach dem Ausdruck körperlicher Fülle, nach der Betonung eines organischen Verhältnisses zum Körper wahrnehmen, den Maillol und Henri Laurens (der in der Ausstellung nicht vertreten ist), Henri Matisse und in gewisser Weise Henry Moore teilen.

Gleichermaßen spektakulär wie Maillols »Rivière« war bei der Eröffnungsausstellung des Skulpturengartens 1953 die »Floating Figure« (1927) von Gaston Lachaise, die als eine von nur drei amerikanischen Arbeiten in »Figure in the Garden« zu sehen ist. Der gebürtige Franzose erreichte im ersten Drittel des 20. Jahrhunderts eine unvergleichliche Bedeutung in den USA. Das Museum of Modern Art widmete ihm im Jahr seines Todes die erste Retrospektive eines in den USA tätigen Bild-

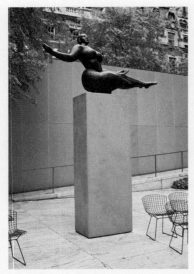

Gaston Lachaise, *Floating Figure*, 1927 (Abb. S. 40)

hauers. Die 1937 angekaufte »Floating Figure« gehört zu den meistausgestellten Arbeiten des Skulpturengartens.

Gaston Lachaise hatte ab 1898 in seiner Geburtsstadt Paris studiert, dort die beginnende Moderne und die Rivalität zwischen Rodin und Maillol miterlebt und als junger Künstler Beachtung gefunden. 1904 übersiedelte er mit seiner amerikanischen Geliebten nach New York, wo er zum erfolgreichsten Bildhauer seiner Generation aufstieg.

Zentrale Momente der »Floating Figure« sind die Suche nach einer neuen Form der Körperlichkeit und nach einer Darstellung der Bewegung, die die Skulptur mit dem Raum kommunizieren lässt. Diese drei Aspekte sind in einer einzigen bildhauerischen Gestalt so dicht zusammengefasst wie in kaum einer zweiten Skulptur des 20. Jahrhunderts. Auf den ersten Blick glaubt man, einer gymnastischen Übung beizuwohnen, wobei die pralle, von der Welt der Plakate in den damaligen amerikanischen Großstädten beeinflusste Körperdarstellung der europäischen Tradition der Skulptur entgeht.

Anders als in der Malerei, wo etwa Georgia O'Keeffe und Edward Hopper auch in Europa im breiten Publikum angekommen sind, hat eine europäische Rezeption der amerikanischen Skulptur vor Barnett Newman, Tony Smith und der Minimal Art bis heute nicht stattgefunden. Im ersten bedeutenden Buch über die Moderne in der Skulptur, das nach 1945 in Deutschland erschienen ist, Eduard Triers »Moderne Plastik. Von Auguste Rodin bis Marino Marini« (1954), findet sich kein Wort zu einer in den USA entstehenden, eigenen bildhauerischen Tradition. Marcel Duchamp lebte als Künstler, Berater und Händler seit 1915 meist in New York, wurde aber trotz seines Einflusses in den USA in seiner französischen Heimat bis 1959 nicht wahrgenommen. Die Kontinente waren noch weit voneinander entfernt. Selbst Werner Hofmann schrieb in seiner hervorragenden Geschichte der Plastik im 20. Jahrhundert, Lachaise habe in der »Floating Figure« »mit seinen athletischen Fruchtbarkeitssymbolen [...] ein weiteres Symptom für die gefährliche Verflachung vom Humanismus zum Sensualismus« geschaffen.[14]

In formgeschichtlicher Hinsicht ist die Frage interessant, welche Rolle die »Floating Figure« für die Herausbildung einer eigenständigen amerikanischen Skulptur im 20. Jahrhundert spielte. Alexander Calder, Tony Smith, Barnett Newman und die Künstler der Minimal Art haben – im Gefolge der Privilegierung der Fläche, die bereits bei Nadelman und Lachaise angelegt ist – radikale Schritte im Sinn eines neuen Skulpturbegriffes gesetzt. Dieser expansive Skulpturbegriff der sechziger und siebziger Jahre war im Skulpturengarten von Philip Johnson

kaum darstellbar, wirkt aber wiederum zurück auf die aktuelle Generation, die in »Figure in the Garden« durch Katharina Fritsch und Tom Otterness vertreten ist. In der Vorwegnahme eines anorganischen Gestaltbegriffs, der sich nicht mehr an der Modellierung vor realen Körpern orientiert wie bei Rodin und Maillol, sondern an Werbebildern, wie sie in der ersten Hälfte des 20. Jahrhunderts das New Yorker Stadtbild bereits bestimmten, hat die-

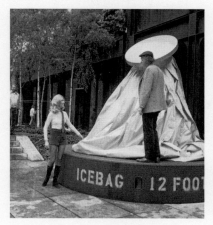

se nordamerikanische Tradition überraschend viel mit aktuellen Fragen der Bildhauerei zu tun. Die monumen- talisierende Aufgeblasenheit und der Hyperrealismus der weiblichen Figuren von Gaston Lachaise führen auf untergründigen Wegen zu Claes Oldenburgs »soft sculptures«, die ab 1963 in New York nochmals einen neuen Weg gegenüber der europäisch bestimmten Skulptur der ersten Hälfte des 20. Jahrhunderts ein- schlugen und wiederum für Fritsch und Otterness und ihren Begriff von der Skulptur maßgeblich wurden.

Claes Oldenburg baut *Ice Bag, Scale C* in der Ausstellung »Technics and Creativity: Selections from Gemini G.E.L.« auf, 1971 (Abb. S. 43)

Besonders aufschlussreich ist bei »Figure in the Gar- den« die unmittelbare Nachbarschaft zwischen der Figur von Lachaise und dem vollfigürlichen Akt von Maillols »Rivière«. Maillol wurde in Frankreich seinerzeit als der wichtigste Bildhauer des 20. Jahrhunderts gefeiert. Er könnte durchaus auf Lachaises damals sehr bekannte »Floating Figure« geantwortet haben – mit einer ebenso extremen Geste, die zugleich die Darstellung der Bewegung auf die Spitze treibt und das neoklassizistische Ideal gegenüber der Deformation und Objekthaftigkeit bei Lachaise behauptet. Ebenso deutlich ist das Thema der Rückkehr und Versöhnung der gebärfähigen Frau mit dem Wasser, der Na- tur und einer daraus abgeleiteten »organischen« Konzeption der Gesellschaft. Das entsprach im Jahr der Fertigstellung 1943 durchaus der Ideologie des Vichy-Regimes, womit die Skulptur auch vermittelt, dass diese politischen Be- wegungen sich nicht als reaktionärer Schritt rückwärts, sondern als Ablösung von einer als dekadent wahrgenommenen Moderne verstanden, die für Maillol in der Hypersensibilität Rodins verkörpert war.

Die wesentlichen Themen der figurativen Skulptur im 20. Jahrhundert – die Bewegung, der organische Körperbegriff und das dynamische Verhältnis der Skulptur zum Raum – sind auch an den frühen amerikanischen Skulpturen ab- lesbar, die die Ausstellung zeigt. »Man in the Open Air« von Elie Nadelman von ca. 1915 bringt Bewegung und Organik durch den Kontrapost und eine fein- gliedrige Linienführung mit Betonung der Vertikalen zum Ausdruck, die in gewisser Weise bereits Giacomettis Skulpturen der letzten Schaffensjahrzehnte

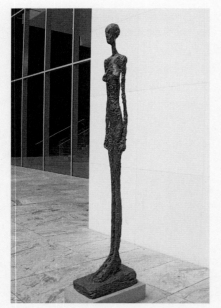

Alberto Giacometti, *Grande Femme III*, 1960 (Abb. S. 49)

– darunter in der Ausstellung »Grande Femme III« – erahnen lässt. Im Vergleich beider Skulpturen wird Giacomettis Figur als eine über Jahrzehnte betriebene Präzisierung des Begriffs der Figur gegenüber den traditionellen Funktionen der Darstellung kenntlich, die neben der aufs Äußerste intensivierten Beziehung von Figur und Raum die Tragweite der Arbeit dieses Künstlers ausmacht.

Nadelmans Plastik ist 45 Jahre vor Giacomettis Skulptur entstanden und vermittelt den Elan eines künstlerischen Aufbruchs. 1915 stand New York noch unter dem Eindruck der »Armory Show« von 1913, der ersten umfassenden Ausstellung moderner Kunst in den USA, die nur ein Jahr nach der ersten übergreifenden Ausstellung der Moderne in Europa, dem Kölner »Sonderbund«, stattgefunden hatte. Zuvor hatten bereits mehrere Generationen amerikanischer Kunststudenten in Europa studiert und anschließend in den USA jene Kreise aus Sammlern und Museumsgründern gebildet, die die Museumsgeschichte des 20. Jahrhunderts wesentlich mitbestimmen sollten. Die Gründung des Museum of Modern Art war Teil dieses kulturellen Transfers, der um die Mitte des 19. Jahrhunderts eingesetzt hatte.

Eliasz Nadelman war 1902 im Alter von 20 Jahren aus seiner damals zum Zarenreich gehörenden Geburtsstadt Warschau nach München übersiedelt und zwei Jahre später nach Paris weitergezogen, wo er als eines der großen Talente 1909 in der wichtigen Galerie Druet ausstellte, von Leo Stein gesammelt wurde und bereits früh einige wesentliche Exempel der kubistischen Skulptur schuf. Nach dem Ausbruch des Ersten Weltkriegs übersiedelte er – sich ebenso wie Marcel Duchamp dem Kriegseinsatz entziehend – nach New York. »Man in the Open Air« von ca. 1915 wurde sein größter Erfolg in der neuen Heimat. Zugleich gelingt ihm die Verdichtung der europäischen Avantgarde, vom Jugendstil bis zur Auflösung der Statuenform, in einer realistischen Form. Die Verbindung einer abstrahierten männlichen Figur mit dem modernen Hut und der Straßensituation eröffnen ein skulpturales Repertoire, das die Themenbereiche der nordamerikanischen Kunst des frühen 20. Jahrhunderts vorbereitet: die Alltagswelt und einen nicht zuletzt in lokalen künstlerischen Traditionen verankerten Realismus. Das Museum of Modern Art richtete Nadelman 1948, zwei Jahre nach dessen Tod, eine Retrospektive aus, die auch in den Museen von Boston und Baltimore zu sehen war.[15]

Es zählt zu den Stärken dieser ohne Unterbrechung seit den dreißiger Jahren aufgebauten Sammlung, überraschende Dialoge herstellen zu können. Nadelmans artifiziell erscheinende Gestalt des »Man in the Open Air« hat die zeitgenössischen Künstler der Ausstellung »Figure in the Garden«, Katharina Fritsch und Tom Otterness, überaus interessiert. Otterness hat sich intensiv mit Nadelmans Ideen und seinem Werdegang beschäftigt, seiner ersten großen Folk- und Outsider-Art-Sammlung in den USA und seinem frühen Versuch, eine nicht europäische Tradition der Skulptur aus den lokalen Traditionen abzuleiten. In mehrerlei Hinsicht war Elie Nadelman ein Wegbereiter der weitreichenden Vereinfachungen, die der amerikanischen Kunst nach 1945 gelangen. Für Katharina Fritsch wiederum gehört diese Skulptur von Nadelman – neben den benachbarten von Maillol und Matisse, aber auch Sintenis' »Daphne« – zu den ihre eigene Arbeit am stärksten berührenden Skulpturen in der Konstellation von »Figure in the Garden«. »Man in the Open Air« ist eine fast schon zur Pop Art weitergedachte Jugendstilgestalt, in der sehr früh ein nicht organischer Körperbegriff angelegt scheint.

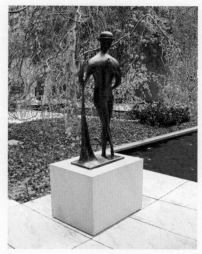

Elie Nadelman, *Man in the Open Air*, ca. 1915 (Abb. S. 47)

Gegenüber dem stolzen Optimismus von Nadelman und Lachaise sind die Zeugnisse der Zeit nach dem Zweiten Weltkrieg in »Figure in the Garden« von einer Skepsis gegenüber den Möglichkeiten des Menschenbilds in der Skulptur geprägt. Henry Moores Vision der Plastik war für die Mitte des 20. Jahrhunderts wohl entscheidend. »Family Group« (1948/1949, Bronzeguss von 1950, erworben 1951) zeigt bereits ein Merkmal, das für alle Menschendarstellungen in der Ausstellung charakteristisch wird, die zwischen 1945 und 1988 entstanden. Die Figuren weisen – im Gegensatz zu sämtlichen gezeigten Skulpturen der Vorkriegszeit – kein konkretes Gesicht auf. Es ist teils durch eine Fläche, teils durch ein Zeichen ersetzt. Moores »Family Group« handelt von der existenzialistischen Selbstbefragung des Menschen und der Wiederherstellung der zwischenmenschlichen Bande nach der Katastrophe des Zweiten Weltkriegs, wobei die raumgreifende Dynamik der Skulptur sich in diesem Falle gewissermaßen nach innen, im Zueinanderwenden der drei Figuren entwickelt. Diese Skulptur

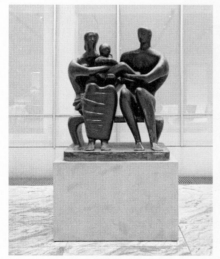

Henry Moore, *Family Group*, 1948/1949 (Abb. S. 49)

ist das einzige mehrfigürliche Werk in der Ausstellung neben Fritschs »Figurengruppe« und auch die einzige weitere Arbeit, die sowohl weibliche als auch männliche Gestalten zeigt.

Max Ernst empfand skulpturales Gestalten zeitlebens als Entspannung von der Malerei. Seine Skulpturen strahlen das auch aus und haben gerade durch den

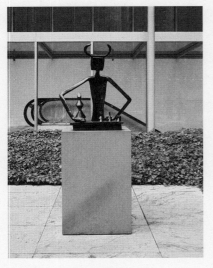

Max Ernst, *The King Playing with the Queen*, 1944
(Abb. S. 51)

lockeren Umgang mit dem Medium einen wesentlichen Einfluss auf die Skulptur der Gegenwart ausgeübt. Im Zusammenhang dieser Ausstellung schlägt Ernsts »The King Playing with the Queen« eine andere Tonart an. Die Skulptur entstand 1944, als der Künstler in den USA lebte und in engem Kontakt mit dem passionierten Schachspieler Marcel Duchamp stand. Ernsts frühe Bronzeskulptur ist wie ein Schachspiel angeordnet, dessen Spieler die Schachfiguren selbst sind. Der König, den er beeinflusst von der Mythologie der nordamerikanischen Indianer entwarf, kontrastiert mit den früheren Werken durch seine souveräne Stellung. Ein kleiner Knick im Oberkörper genügt, um die zweidimensionale Fläche ins Dreidimensionale zu wenden und den Raum zwischen den beiden Spielern dynamisch zu definieren. Völlig unpathetisch entsteht eine verneigende Bewegung des Königs zur Königin, wodurch diese Skulptur in der Aufstellung im Skulpturengarten zwischen den statischen Gestalten der »Figurengruppe« in der Mitte des Gartens und dem überaus bewegten »Saint Jean« am westlichen Rand vermittelt. Die Figur wurde aus Alltagsgegenständen wie Trinkbechern, Autoteilen usw. aufgebaut, dann modelliert und gegossen. Daraus ergibt sich ihre Frische und die Vorwegnahme der Verwendung von Alltagsgegenständen in der Skulptur, Malerei und Objektkunst ab den fünfziger Jahren.

Als Gegenstück zur Plastik von Max Ernst aus der surrealistischen Bewegung heraus erscheint Joan Mirós »Oiseau lunaire« von 1966 (seit 1994 in der Sammlung), die höchste Plastik in der Ausstellung neben Giacomettis »Grande Femme III« und die Arbeit mit dem größten Volumen. Auch sie zeigt sich als Malerplastik spielerisch und frei im Umgang mit dem bildhauerischen Repertoire und findet damit zu einem Begriff des Körpers und des Volumens, der sich sehr deutlich von jenem unterscheidet, den noch Maillol und Moore voraussetzten. Trotz oder gerade wegen des großen Volumens, das jedoch nicht monumental wirkt, erscheint »Oiseau lunaire« wie ein imaginiertes Objekt, das, abgekoppelt von der Nachahmung der Natur, zahlreiche Bedeutungsebenen aufweist. Wie Moore und Ernst sucht auch Miró mit seinem »Oiseau lunaire« nach der Aktualisierung ei-

nes formalen, mythologischen und rituellen Potenzials der frühgeschichtlichen Skulptur, das der Bildhauerei in der zunehmend integrierten Welt der Konsumgesellschaft der Nachkriegszeit eine eigenständige Funktion neben der Warenwelt verleiht.

Max Ernst lebte und arbeitete bis 1976, Joan Miró bis 1983, Henry Moore bis 1986. Vor diesem Hintergrund erweist sich der scheinbar epochale Bruch zwischen der klassischen Moderne und der zeitgenössischen Kunst als weniger eindeutig. Das gilt auch für »Head« (1988/1989) von Tom Otterness, entstanden als Teil einer mehrteiligen Skulptur für den Battery Park in Manhattan. Wie in seinem übrigen Werk ging Otterness nicht von einem konkreten Kopf aus, sondern vom allgemeinen Begriff eines Kopfes, den er frei modellierte und anschließend vergrößerte. Die bereits bei Moore, Ernst

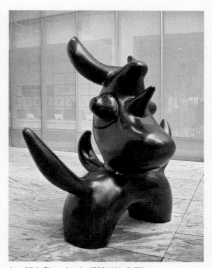

Joan Miró, *Oiseau lunaire*, 1966 (Abb. S. 52)

und Miró angedeutete Abwendung vom organischen Körperbegriff der früheren Moderne wird nun konsequent vollzogen. Obwohl er zu schlafen scheint, ist Otterness' »Head« bewusst als künstliche Gestalt angelegt, nicht als lebendiger Organismus modelliert. Die äußere Form ist nicht Ausdruck innerer Organe und ihrer Bewegung, sondern Bild, Zeichen oder organloser Körper, an den sich die unterschiedlichsten Affekte und Emotionen heften können. Dieser nicht organische Körperbegriff kennzeichnet auch die neun Figuren von Katharina Fritsch.

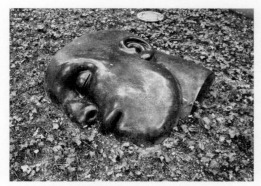

Tom Otterness, *Head*, 1988/1989 (Abb. S. 70)

Otterness' Skulptur ist Teil eines Ensembles, durch das im Battery Park eine menschliche Figur gleichsam aus dem Boden aufzutauchen scheint. In seinem Frühwerk von der Minimal Art angeregt, hat Otterness hier den Schritt aus der Vertikalität der traditionellen Skulptur in die Horizontale vollzogen, mit dem Minimal und Land Art seit den sechziger Jahren die Paradigmen der Skulptur erneuerten. Ebenso deutlich sind der soziale Anlass und die soziale Bedeutung der Skulptur, die im Park auf ein Publikum aus Passanten trifft, das überwiegend nicht mit einem geschulten Kunstbegriff auf das Gesehene reagiert. In dieser Hinsicht kommt dem Umstand eine besondere Bedeutung zu, dass »Head« aufgrund einiger formaler Merkmale als Kopf eines Afroamerikaners begriffen werden kann, was auch durch die Farblosigkeit der Bronze in der Schwebe gehalten wird. Die räumliche Nähe

Robert Fleck

zu Maillols »La Méditerranée« im Skulpturengarten demonstriert zwei unterschiedliche Anwendungen einer betont klassisch ausgeprägten Form, die bei Otterness nicht mit einem klassizistischen Kunstprogramm verbunden, sondern gleichsam nur geborgt ist, um die Feierlichkeit der Skulptur zu verstärken. In der isolierten Präsentation des Kopfes im Rahmen der Ausstellung, in die der Künstler eingebunden war, erscheint die Skulptur auch wie ein Grabstein für einen unbekannten – vielleicht afroamerikanischen – Mitbürger.

In diesem vielfältigen Dialog über 130 Jahre figurativer Skulptur erweist sich die »Figurengruppe« von Katharina Fritsch noch deutlicher als eine zentrale skulpturale Arbeit der letzten Jahre. Die Gruppe ist klar aufgebaut. Jede Gestalt ist von allen Seiten gleichansichtig intensiv. Zudem ist die Gruppe so gestellt, dass sie von allen Seiten gleichermaßen stimmig erscheint. Neben diesem klassischen Bildhauergedanken steht diese Arbeit auch durch die starke modellierende Überarbeitung der Rohformen in Beziehung zur bildhauerischen Tradition. Seit ihren ersten bildhauerischen Arbeiten 1979 geht Katharina Fritsch bewusst von bestehenden Formen aus, um eine Bildhaftigkeit der Skulptur zu erreichen. Dementsprechend sind die einzelnen Figuren der Gruppe von menschlichen Modellen und vorgefundenen Gegenständen abgenommen, teils durch einen Gipsabguss, teils mithilfe von 3-D-Scan-Verfahren, die erst seit wenigen Jahren aus der Industrie zur Verfügung stehen. Daraus ergibt sich der anorganische Körperbegriff der Figuren, die nicht mehr modellierend aufgebaut, sondern zunächst als Gegenstände produziert sind. Anschließend werden sie modellierend überarbeitet, da es nicht darum geht, ein Objekt durch seine Reproduktion oder Vergrößerung als Readymade in den Kunstkontext zu stellen, sondern darum, dreidimensionale Bilder zu schaffen, deren Motive auf flüchtigen Kindheitserinnerungen beruhen und eine Beziehung zum kollektiven Unbewussten, zu den Emotionen des Individuums besitzen, ohne Zeichen für etwas oder Fragmente der zeitgenössischen Medienwelt zu sein.

Innerhalb der Ausstellung sticht die »Figurengruppe« durch die Mehrfarbigkeit und die strahlende, aber matte Farbigkeit heraus, die den Skulpturen eine unbestimmbare Erscheinungsform gibt. Farbige Objekte hatte Katharina Fritsch bereits während ihres Studiums hergestellt. Eine Schlüsselarbeit war die erste »Madonna« von 1982, ein gelb bemaltes Souvenirobjekt. Die »Figurengruppe« entstand im Atelier in Düsseldorf aus dem Gedanken, aus mehreren, in anderen Zusammenhängen entstandenen Figuren eine neue, komplexe Skulptur hervorgehen zu lassen. Die Auswahl der Farben für die einzelnen Figuren erfolgte durchaus gezielt. Neben der Komposition und der Entscheidung, alle Figuren in denselben Maßstab zu versetzen, stellt sie den wesentlichen Vorgang bei der Entstehung der »Figurengruppe« dar.

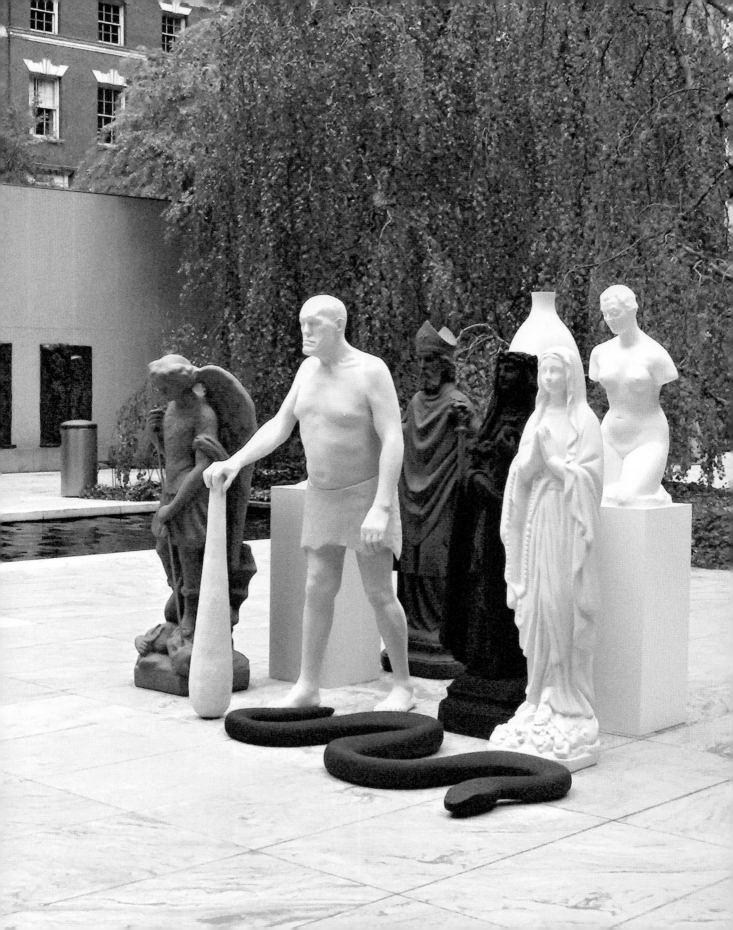

Die makellose, matte Bemalung mit besonders reinen Farben weist das Umgebungslicht gleichsam von den Figuren ab und lässt diese dadurch unwirklich erscheinen. Daraus wie aus der unauflösbaren Gegensätzlichkeit der Gestalten gehen die plastische Mehrdeutigkeit und das offene Bedeutungsspektrum der »Figurengruppe« hervor. Die unwirkliche Erscheinung von Gestalten, die zugleich sehr präsent sind, und der anorganische Körperbegriff bringen elementare Erfahrungen der Gegenwart zum Ausdruck.

Endnoten

1 Vgl. Susan Sontag, Kunst und Antikunst, München, Wien 1980.

2 Vgl. Werner Hofmann, Das Atelier. Courbets Jahrhundertbild, München 2010.

3 Vgl. Alfred H. Barr Jr. (Hg.), Painting and Sculpture in The Museum of Modern Art, New York 1948, S. 248, 321, 325.

4 Renée Sintenis. Mit Beiträgen von Rudolf Hagelstange, Carl Georg Heise, Paul Appel, Berlin 1947; »Daphne« in zwei guten Abbildungen auf den Tafeln 84 und 85.

5 Alfred H. Barr Jr., Matisse. His Art and His Public, New York 1951.

6 Alfred H. Barr Jr., Picasso. Fifty Years of His Art, New York 1946.

7 Zur Entstehung und zum architektonischen Programm des Gartens folge ich der hervorragenden Studie von Mirka Beneš, »A Modern Classic. The Abby Aldrich Rockefeller Sculpture Garden«, in: Philip Johnson and The Museum of Modern Art (Studies in Modern Art 6), New York 1998, S. 105–151.

8 Barr, zit. n. Beneš, ebd., S. 116.

9 Die Ausstellung mit dem Titel »Mies van der Rohe« wurde vom 16. September 1947 bis zum 25. Januar 1948 gezeigt. Heute verwahrt das Museum of Modern Art das Mies van der Rohe Archive.

10 Der bedeutende Architektur- und Kunstkritiker Sigfrid Giedion soll, als Johnson ihm das Modell des Skulpturengartens zeigte, ausgerufen haben: »At last, a piazza in New York!«; zit. n. Beneš, a.a.O., S. 137.

11 Philip Johnson, zit. n. ebd., S. 128.

12 Philip Johnson, zit. n. ebd., S. 126, 132.

13 Vgl. Werner Hofmann, Plastik im 20. Jahrhundert, Frankfurt am Main 1958. Das in der Folge weitverbreitete Buch wurde überwiegend in der Bibliothek des Museum of Modern Art geschrieben. Vgl. Robert Fleck, Werner Hofmann – Ein Gespräch, Hamburg (im Erscheinen).

14 Hofmann, ebd., S. 61.

15 Lincoln Kirstein, The Sculpture of Elie Nadelman, Ausstellungskatalog Museum of Modern Art, New York / Institute of Contemporary Art, Boston / Baltimore Museum of Art, New York 1948.